How To Draw
CARICATURES

Written, illustrated, and designed by
LENN REDMAN

CB
CONTEMPORARY BOOKS
A TRIBUNE NEW MEDIA/EDUCATION COMPANY

Library of Congress Cataloging in Publication Data

Redman, Lenn.
 How to draw caricatures.

 Includes index.
 1. Cartooning. I. Title.
NC1320.R42 1984 741.5 83-18963
ISBN 0-8092-5685-1

**Photographs of Lenn Redman's hands on title page
and page 158 by Vincent Rondone.**

Published by Contemporary Books, Inc.
Two Prudential Plaza, Chicago, Illinois 60601-6790
Manufactured in the United States of America
International Standard Book Number: 0-8092-5685-1

I dedicate this book to the wonderful people whose photographs and caricatures appear herein. I am grateful to them for the trust they showed in me. They all gave me permission to reproduce their likenesses and then analyze their faces for caricatural interpretation. That took courage and trust in my judgment, for they did so in advance, having seen neither the photographs, caricatures, nor written text.

They were unreservedly cooperative and displayed good humor while posing for their photographs. They have my profoundest respect.

Contents

LENN REDMAN—Teaching at Los Angeles Community Services
Pierce College, Woodland Hills, California

Acknowledgments

Special thanks to Rosemary Tharps for assembling for this book a large variety of people who have subsequently become my friends. Her cooperation in this respect saved me much valuable time.

I am also grateful to Vincent Rondone for opening his studio to me, arranging proper lighting, and supervising me as I photographed these wonderful people.

Introduction

This book is written with the desire to aid a vast range of people, including professional artists, art students, and those who have no interest in art per se but who want to learn how to draw caricatures just for the fun of it.

There has been a need for such a book for a very long time. I became aware of it at age 16 when I first developed an interest in caricaturing. With a strong desire to learn how to draw caricatures, I bought every book on the subject I could find—and have continued to do so until this day. My library consists of anthologies of caricatures, anecdotes of the artists' experiences, photographs of the artists engaged in drawing celebrities, and histories on the art. But other than a page I wrote on the subject in *Our Wonderful World*, a young people's encyclopedia published by the Spencer Press, Inc., in 1955, I have never seen a single, instructional guide on how to draw caricatures. The result is that some of the finest artists—artists who can wrap rings around me with their drawings and paintings of portraits, landscapes, seascapes, still lifes—are completely lost when it comes to drawing caricatures. I hope this book helps them—but I am particularly anxious to help the art student who wants to include caricaturing among his or her studies, and those people who are interested in learning to draw caricatures just for the fun of it.

I found out what a terrific hobby caricaturing is when I first began teaching. It was at an adult evening class at the Chicago Central YMCA early in 1963. I had expected my students to be young with ambitions to become professional cartoonists. What a surprise it was for me on the first day of the semester to see my class was composed of many people who were middle-aged and older! One of my students was in his 80s. They were from all walks of life. A doctor, a mathematics teacher, and a window washer were among them.

Why has there been such a dearth of information on how to draw caricatures? I believe it is due to the erroneous belief that caricaturing cannot be taught—that those of us who are able to draw them are endowed with something special in our genes. Perhaps to some extent that is true, but I know from experience as a teacher that everyone, including those who may have no special artistic talent, can learn to draw caricatures at least well enough for their own amusement and enjoyment. Believe me, it *is* enjoyable.

TOOLS OF THE TRADE

The beginner need not be concerned over the quality of paper to draw on. Ordinary typing paper is satisfactory. Even cheap newsprint will suffice. But the type of pencil you use *will* make a difference. Soft lead pencils are better than hard lead pencils for caricaturing. The hard leads are usually categorized with the letter H; they are used for mechanical drawing. The soft leads are categorized with the letter B. They range from B1 to B6—the higher the number, the softer the lead. B3s are ideal; they make satisfactorily dark broad lines that run smoothly over the paper. For the time being, stay away from carbon pencils and charcoal pencils. They tend to drag over the paper and will slow you down. Later, they'll serve you well—after you have learned how to exaggerate your subjects' features. At that time you may wish to render your caricatures with various shaded effects accomplishable with carbon, charcoal, and other media.

When you are ready to draw with pen and ink, you will need a better grade paper. Bristle board is a good one. There are others—ask your artist supply dealer for recommendations.

Pen and ink is an excellent medium. Most artists use this medium for line drawings that are to be reproduced. I use pen and ink for my small drawings but I prefer felt markers when I draw large. Their lines dry while being applied, thus enabling me to draw quickly without having to worry about smudging. The tips of the markers come in various thicknesses and though it is not possible to draw as fine a line with a marker as it is with a pen, they work just right for me. I usually draw my caricatures on such a large scale that when they are reduced to a smaller size for publication, the lines become thin and they look like they had been drawn with pen and ink.

Most of the caricatures drawn from photographs in this book were drawn from 50 to 100 percent larger than shown. The ones on pages 14 through 17 measured about seven inches from the top of the head to the bottom of the chin. With the exception of a few of the celebrities who were caricatured from newspaper and magazine clippings, they were drawn as an entertainment feature at parties, banquets, and conventions. I drew them with a waxed china marking pencil on the lens of an overhead projector so that everyone present was able to watch them develop on a screen. The projector's mechanism requires the drawings be done with a waxed pencil on thin sheets of acetate or celluloid. It's a relatively easy device to work on, for when I make a mistake I simply wipe it off with a rag. None of the drawings took me more than 15 minutes—most of them only 5 to 7 minutes.

What Is a Caricature?

I define caricature as an exaggerated likeness of a person made by emphasizing all of the features that make the person different from everyone else. It is not the exaggeration of one's worst features. That is a carry-over from the days, 100 years and more ago, when humor was almost always based on cruelty and when the caricaturist's intent was to insult his subject. Today, most caricaturists draw for artistic challenge or for pure fun. At least that is the way I go at it—for money, too.

Many people think that a caricature is necessarily a graphic distortion of a face. Not true! The essence of a caricature is *exaggeration—not distortion*. Exaggeration is the overemphasis of truth. Distortion is a complete denial of truth. If you were to draw your subject's large round eyes larger and rounder than they are, you'd be exaggerating a truth, thus increasing your possibility for achieving a likeness. Obviously, if you were to draw those same eyes small and narrow, you'd be distorting the truth, thus denying yourself any possibility of achieving a likeness. However, there are extraordinarily creative artists who succeed in distorting without sacrificing their caricature's required exaggeration for obtaining a likeness. We'll get into that type of caricaturing later.

LEARNING TO SEE

How can one know what to exaggerate? The answer lies in understanding what we see. We recognize a friend, relative, or acquaintance at a glance, but do we understand what we see in the individual that makes him recognizable? Most people don't. Understanding the makeup of what you see is much more important than knowing what materials to use or how to hold your pen, pencil, brush, or felt marker. It's the *brain* that creates. The tools we use are important but secondary.

When you are about to begin drawing, you should make the following observations: Which of your subject's features are larger than most people's? Smaller than most people's? Sharper than most people's and rounder than most people's? The distance between the features also needs to be considered. It is not enough to know, for example, that your subject has either large or small eyes. The distance between them and their placement in relation to the other features must be understood before a convincing likeness can be achieved.

At this point it is reasonable to ask how the distinguishing features of a face are determined. How do you know which of the subject's features are further apart or closer together than other people's? How do you know which of the subject's features are larger, smaller, sharper, or rounder than other people's? It doesn't take much of an artist to recognize the obvious. A big nose, large ears, bald head, bushy hair, sunken cheeks are noticeable to everyone. But how about all the John and Jane Does whose faces appear to be ordinary with nothing especially outstanding? The fact is, no face is ordinary. True, some people's distinguishing features are more subtle than others, thus making them more difficult to caricature. Nonetheless, we are all unique in many ways and I have yet to meet anyone whose features are not caricaturable—at least to some extent.

1

THE PRINCIPLE OF RELATIVITY

You want to know how to determine a person's distinguishing characteristics? All right, here is the key—RELATIVITY.

The art of caricaturing was probably as far from Albert Einstein's mind as the things he thought about are distant from the earth. However, as difficult as it is to understand the complexities of his theory of relativity, it inspired me with a workable formula for drawing caricatures. I use the principle that all things are relative—that things appear as they do because of their relationship to each other.

Relativity's truism applies to everything: sizes, distances, speeds, weights, sounds, colors, even personalities and moral standards. Everything! To illustrate: The vertical line on the lower left side of this page is short, isn't it? Now compare it with the vertical line on the lower right side of the page. The left line has by contrast suddenly become long. Observe the square on the upper right corner of page 3. There appears to be no question about its being black. Now turn the page and compare it with the square on page 5 and our former supposition about the blackness of the square on page 3 changes drastically. You can readily see how this method of relative comparisons is applicable to distances, speeds, sounds, and human traits—all of which can be utilized by the caricaturists of the dance, music, literature, oratory, drama, and the graphic arts.

Relativity in the arts can be thought of as having two parts:

1. *The relationship of things to others of their own kind.*
2. *The relationship of things to their surrounding and abutting elements.*

Both parts are at the heart of my method for exaggerating. They constitute my formula for making comparisons.

In appraising Part 1 for caricaturing, I take pleasure in introducing you to a very good and valuable friend of mine, the *In-betweener.* He is valuable because his construction may be used as a frame of reference for determining how to exaggerate your subjects' features. I will show you how to recognize your subject's individuality by comparing him with the In-betweener.

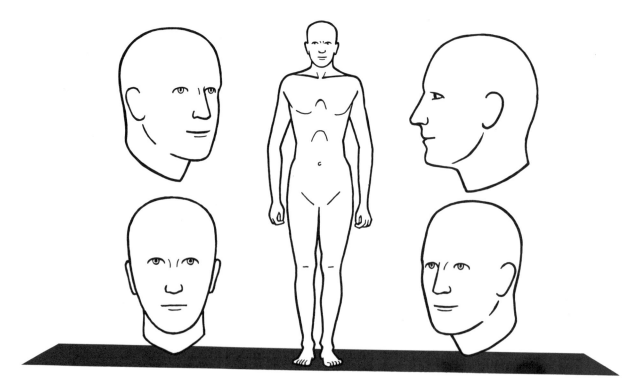

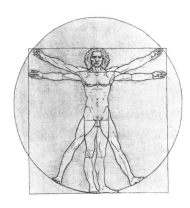

Relativity Part 1:

THE RELATIONSHIP OF THINGS
TO OTHERS OF THEIR OWN KIND

My In-betweener is unique, but you may have seen characters looking something like him in other instructional art books. Frequently referred to as a typical or ideal type, their authors codify the body proportions by showing the relative spaces between various parts of the anatomy. Their opinions differ somewhat—that's only natural since no two people look exactly alike and each artist's standard for judgment is bound to be different.

I believe Leonardo da Vinci was the first to embark on such an approach. The above diagram is the most famous of many he created. Though advanced scientific sources have taught us more about the human anatomy, I credit Leonardo with the genius to start teaching the human construction by way of relative comparisons. There are now a slew of wonderful instructional art books on the market that teach in this manner.

My In-betweener was partially born out of such books, but unlike the authors who proclaim their human configuration as being typical or ideal, I consider my In-betweener's construction as being far from that. The general appearance of the good people who posed for their caricatures in this book is a thousand times more ideal than the In-betweener's appearance; and like all people everywhere, each one of my subjects is typical of himself—no one else.

I said my In-betweener was partially born out of the instructional art books—but my imagination had something to do with it, too. I fantasized a group of morphologists stationed around the world measuring the sizes of and distances between the features, organs, and limbs of personified representative Caucasions, Orientals, Africans, Asians, and all combinations of ethnic peoples. I pictured their respective findings being sent to a central coordinating lab that would total the combined measurements of each and divide them by the number of people measured—the results would constitute median measurements of each part of the anatomy and the spaces between them.

I have fashioned my In-betweener on the basis of what I believe such a survey would show. I think he represents a composite of all the peoples on earth. I think he is facially and physically "in-between" everyone. As such, he works beautifully as one of the keys to my formula. You may use him as a guide and semblance from which to depart while drawing caricatures.

I must emphasize he is only one of the keys. Relativity's two parts consist of other important factors necessary to be considered for drawing artistic caricatures. We'll get into that later, but for the time being we will think exclusively in terms of exaggerating whatever there is about your subject that is different from the In-betweener.

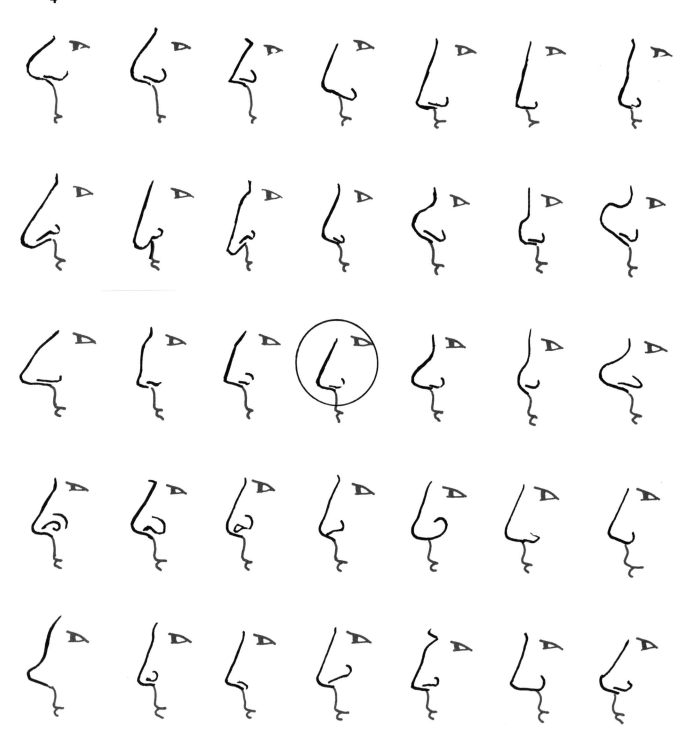

Let us assume these drawings represent all the different kinds of noses in the world. The one circled in the center belongs to the In-Betweener. It's not large. It's not small. It doesn't turn up. It doesn't turn down. It's not concave. It's not convex. His nostrils are neither large nor small. In other words, his nose is a composite of all. It is in between everyone's. By keeping the size and shape of the In-Betweener's nose in mind, it should be easy for you to see how different the subject's nose is from his, thus enabling you to exaggerate the differences.

If your subject's nose is larger than the In-betweener's make it even larger. If it's smaller than the In-betweener's, make it even smaller. If it's narrower, make it more narrow—and so on with all your subject's features. That in substance is what I mean by using Relativity Part 1: *The relationship of things to others of their own kind.* The "others of their own kind" is exemplified by the In-betweener, my valuable gauge for relative anatomic comparisons.

Use the same principle to determine the individuality of all your subject's features.

HERE ARE THE IN-BETWEENER'S FACIAL AND CRANIAL DIMENSIONS

The dotted lines represent the location of the features.
The gray lines should help you determine their location.

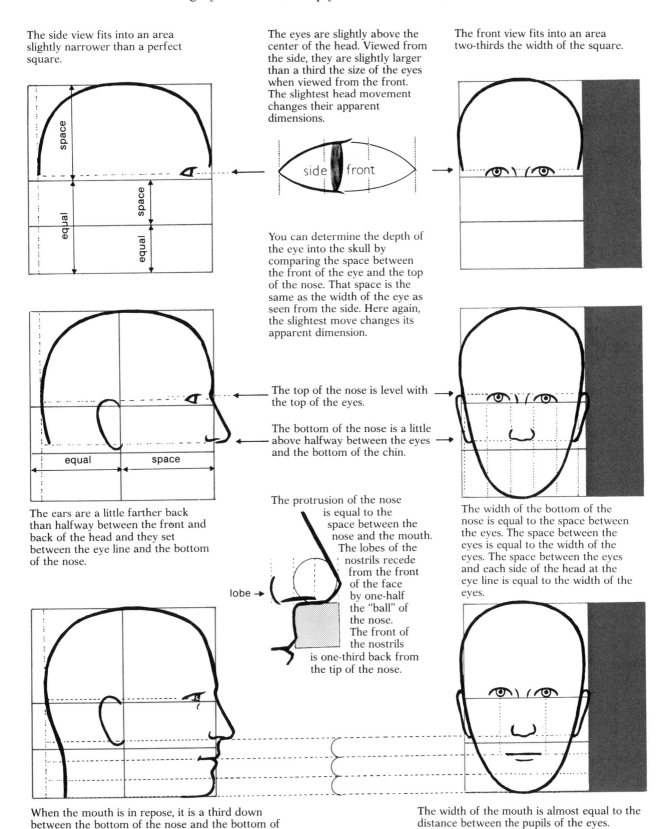

The side view fits into an area slightly narrower than a perfect square.

The eyes are slightly above the center of the head. Viewed from the side, they are slightly larger than a third the size of the eyes when viewed from the front. The slightest head movement changes their apparent dimensions.

The front view fits into an area two-thirds the width of the square.

You can determine the depth of the eye into the skull by comparing the space between the front of the eye and the top of the nose. That space is the same as the width of the eye as seen from the side. Here again, the slightest move changes its apparent dimension.

The top of the nose is level with the top of the eyes.

The bottom of the nose is a little above halfway between the eyes and the bottom of the chin.

The ears are a little farther back than halfway between the front and back of the head and they set between the eye line and the bottom of the nose.

The protrusion of the nose is equal to the space between the nose and the mouth. The lobes of the nostrils recede from the front of the face by one-half the "ball" of the nose. The front of the nostrils is one-third back from the tip of the nose.

The width of the bottom of the nose is equal to the space between the eyes. The space between the eyes is equal to the width of the eyes. The space between the eyes and each side of the head at the eye line is equal to the width of the eyes.

When the mouth is in repose, it is a third down between the bottom of the nose and the bottom of the chin.

The width of the mouth is almost equal to the distance between the pupils of the eyes.

6

HOW YOUR SUBJECT'S PROFILE MIGHT LOOK WITH THE
IN-BETWEENER'S FEATURES BUT SPACED DIFFERENTLY

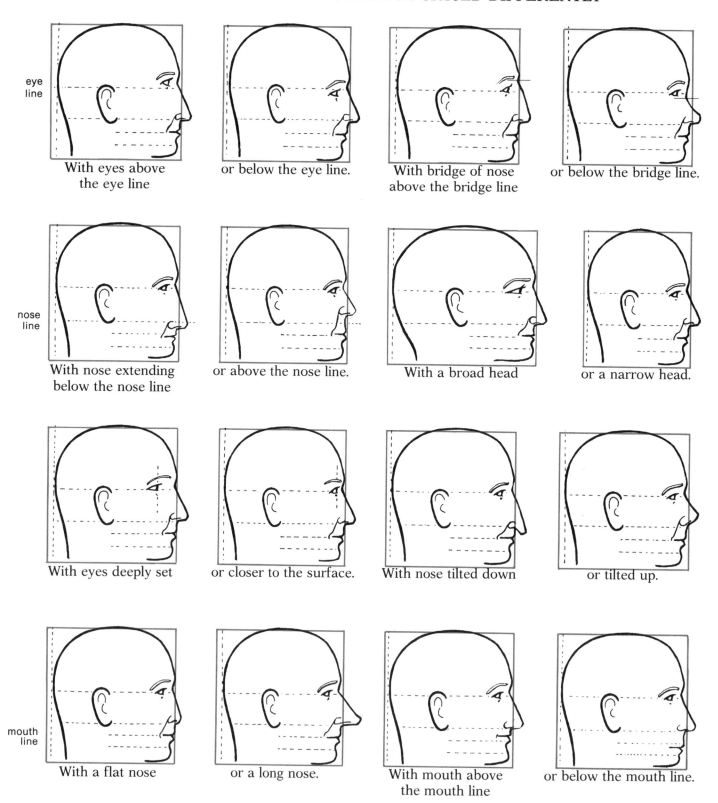

eye
line

With eyes above
the eye line

or below the eye line.

With bridge of nose
above the bridge line

or below the bridge line.

nose
line

With nose extending
below the nose line

or above the nose line.

With a broad head

or a narrow head.

With eyes deeply set

or closer to the surface.

With nose tilted down

or tilted up.

mouth
line

With a flat nose

or a long nose.

With mouth above
the mouth line

or below the mouth line.

MORE ABOUT HOW YOUR SUBJECT'S PROFILE
MIGHT DIFFER FROM THE IN-BETWEENER'S

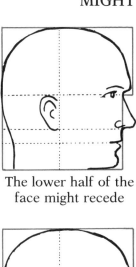

The lower half of the
face might recede

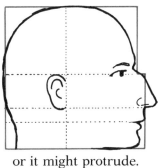

or it might protrude.

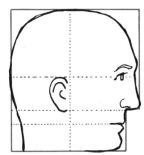

The lower third of
the face might recede

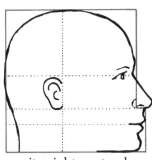

or it might protrude.

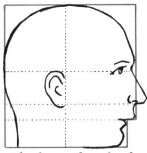

The lower fourth of
the face might recede

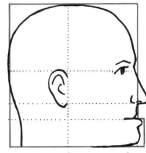

or it might protrude.

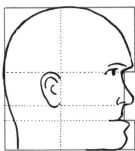

The middle portion of
the face might recede

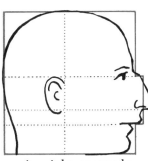

or it might protrude.

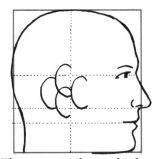

The ears might set high,
low, forward, or back.

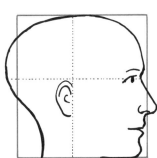

The back of the head
might be shaped like this

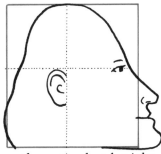

or the entire head might
be shaped like this

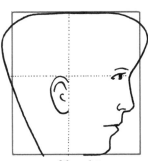

or like this.

THE IN-BETWEENER: FRONT VIEW, *BUT . . .*

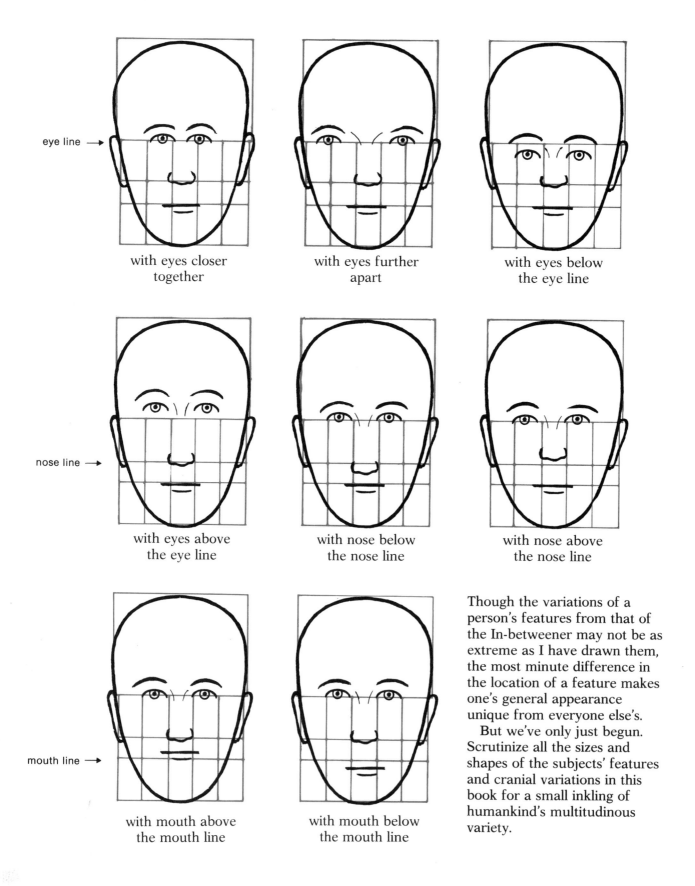

eye line →

with eyes closer
together

with eyes further
apart

with eyes below
the eye line

nose line →

with eyes above
the eye line

with nose below
the nose line

with nose above
the nose line

mouth line →

with mouth above
the mouth line

with mouth below
the mouth line

Though the variations of a person's features from that of the In-betweener may not be as extreme as I have drawn them, the most minute difference in the location of a feature makes one's general appearance unique from everyone else's.

But we've only just begun. Scrutinize all the sizes and shapes of the subjects' features and cranial variations in this book for a small inkling of humankind's multitudinous variety.

HEAD SHAPES

In simplified and exaggerated forms, these drawings epitomize the tremendous range of widths and shapes there are to the human head. Because of this broad range, it is necessary to add another dimension to our frame of reference for drawing caricatures.

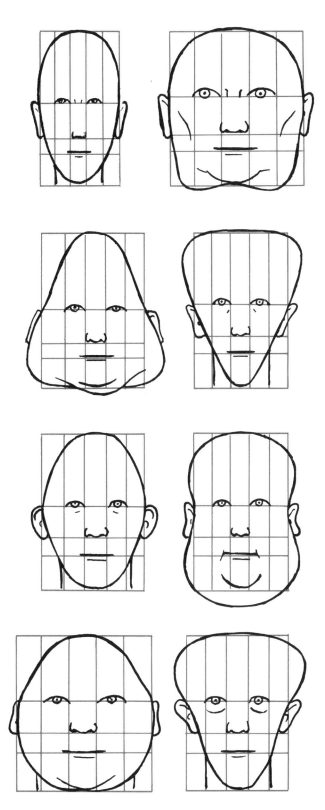

The In-betweener's head is broader at the cranium and narrower at the cheeks, jowls, and eye line. That is true of most people—but not all. Some heads are narrower at the cranium and some, usually due to excessive flesh, are broader at the cheeks, jowls, and eye line. It is the width of the head at the eye line and the size of the eyes that determine the spaces between the eyes and ears. The spaces between and around the eyes may be equal, or, as shown on the preceding page, they may be unequal. Your recognition of these spacing factors is important not only for drawing that particular portion of the face, but also in the way you caricature the rest of the face. For example, eyes that are far apart may make an In-betweener's nose appear contrastingly narrow—in which case, even if your subject has an In-betweener's nose, you'd want to draw it narrower. Or if your subject's eyes are close together, it might make his nose appear contrastingly wide—in which case you'd want to draw it wider.

The spaces between the eyes and the ears are important to consider when drawing a bald-headed person or one whose hair does not obstruct your view. But most people's hair *does* obstruct the view. Is that a problem? No! When hair covers the ears and comes in close to the eyes, the space between the eyes will help determine how to exaggerate the width of the nose—and incidentally, also the mouth. Then too, hair is enjoyably caricaturable. The fun you have with it and the interesting effect it has on your subject's general appearance will more than compensate you for that portion of the head you are unable to see.

HAIR

You may eventually establish a style of caricaturing requiring no more than a scribble for hair. That's all right. If the face is drawn with scribbly lines, the hair should be scribbly. But regardless of the style of drawing you finally master, it's good to know as much about the true construction of hair as possible.

Hair grows, hangs, and sets irregularly. Hair is soft and its strands tend to overlap each other. Individual hairs and strands of hair frequently stand out away from the others. And hair reflects light to some extent: the protruding portions of hair are usually highlighted; the receding portions are more apt to be in shadow.

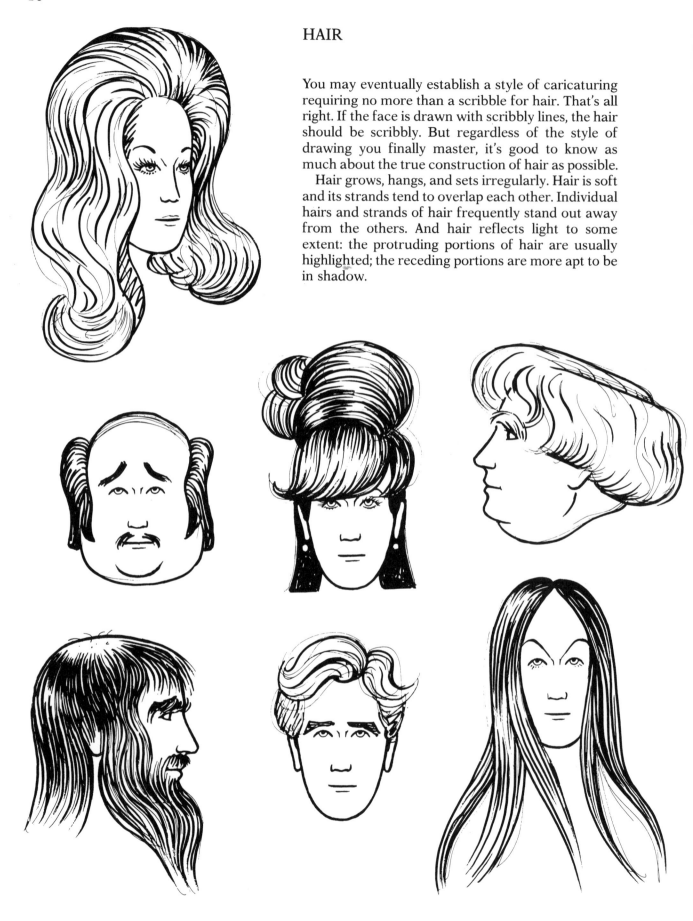

I never cease to marvel at the human head. It boggles my mind that only two eyes, two ears, a nose, a mouth, and a head of hair can produce so many different human likenesses. I've drawn more than 100,000 caricatures of people from life and none looked exactly alike—and that includes so-called identical twins. Though there are now about four and a half billion people on earth, I doubt if there is a single duplication among us. And it doesn't take much to make the difference! For example, observe how different the In-betweener looks here and on the preceding page with just a few extra pounds and different kinds of eyebrows, eyelashes, and hair. Mother Nature, that greatest of all sculptors (and caricaturists) has an easy job molding so large a variety of people.

Now that you're showing an interest in caricaturing, just think what a wealth of material there is to have fun with! You can well imagine the fun I have had over the past several years drawing the caricatures on the next four pages.

The drawings and verse are from a series of posters I designed some years ago. The series is entitled "What Am I?" and is written from the perspective of a collective and composite body of humankind which, in describing and questioning itself, reveals the commonality of all humankind. Pages 78 and 79 are from the same series. The complete poem is printed at the end of the book.

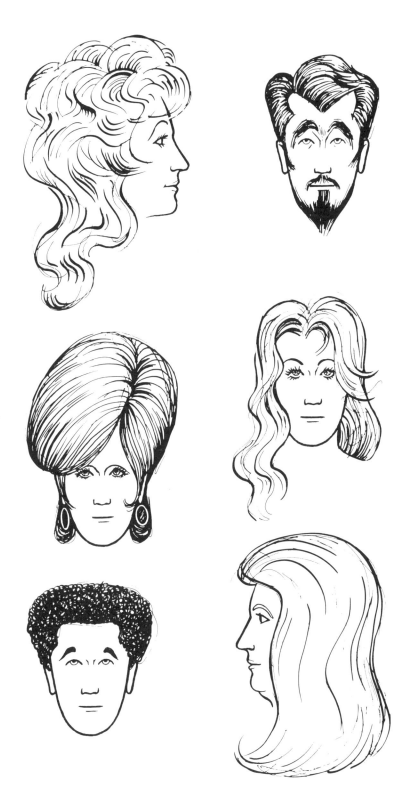

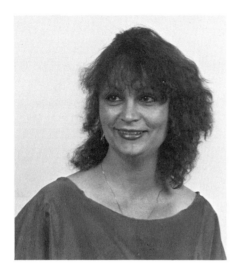

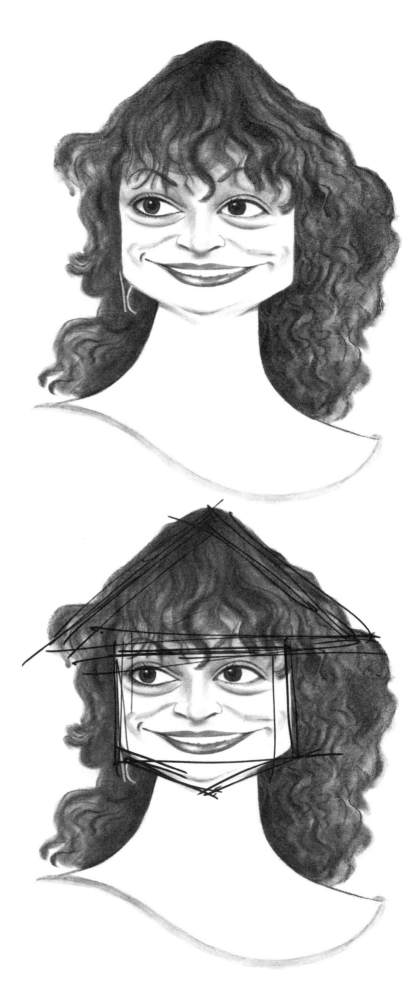

Rosemary doesn't always wear her hair like this but I was glad she did when we took this shot of her. It gave me something extra to exaggerate. The triangular effect of her hair at its crown seems to emphasize the squarishness of her face. The fact that one feature will effect the appearance of another feature is an important factor to consider when caricaturing. It's discussed in my chapter on Relativity Part 2.

Incidentally, this is the only photograph of Rosemary that came out well enough to use. I prefer more, and succeeded in getting from three to four shots of most of the other subjects in this book. Several different views are helpful, because no matter which view a caricaturist might choose to draw from, the others enable him to see facial characteristics that may not be noticeable in only one photograph. In this instance it was not crucial, because Rosemary is a friend of mine and I know very well what she looks like: beautiful, even with triangular hair and squared face.

As far as I'm concerned, all my subjects are beautiful.

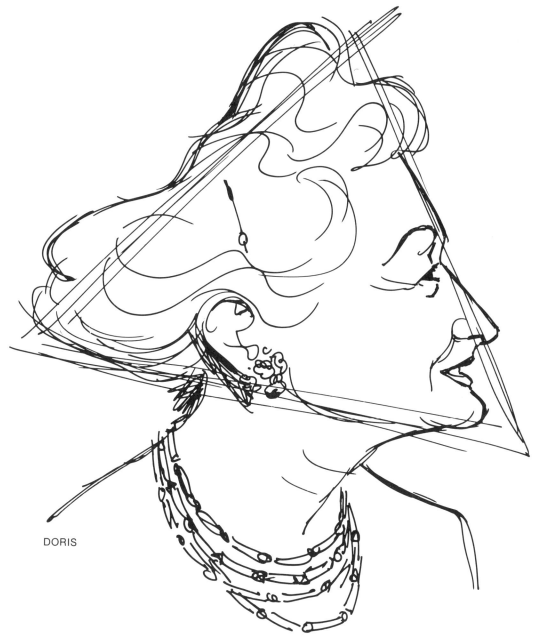

DORIS

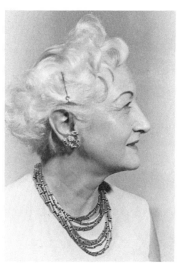

This is better. Two photographs of Doris told me what I wanted to know. Her round face is caricaturable from the front but I preferred to draw her from the side. Her profile juts out slightly from the top of her head to the bottom of her chin—and the way she wears her hair emphasizes it. The total effect it has on her appearance as seen from the side is triangular.

One's appearance can be drastically altered by the way the subject wears his or her hair. Rosemary and Doris are classic examples of what was shown by use of the In-Betweener on pages 10 and 11.

14

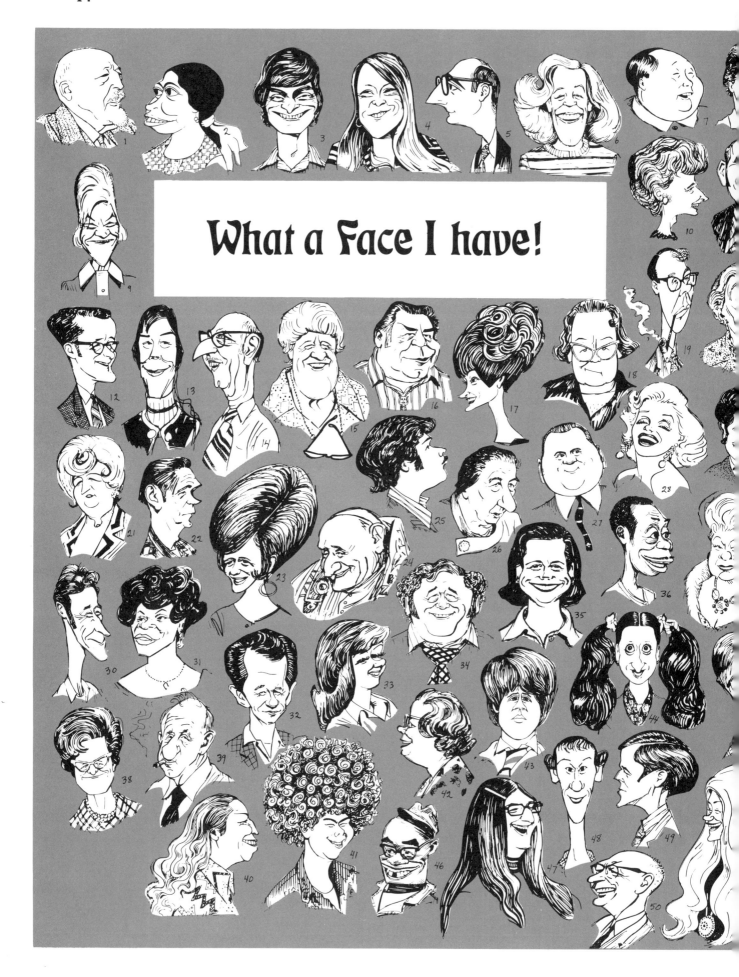

What a Face I have!

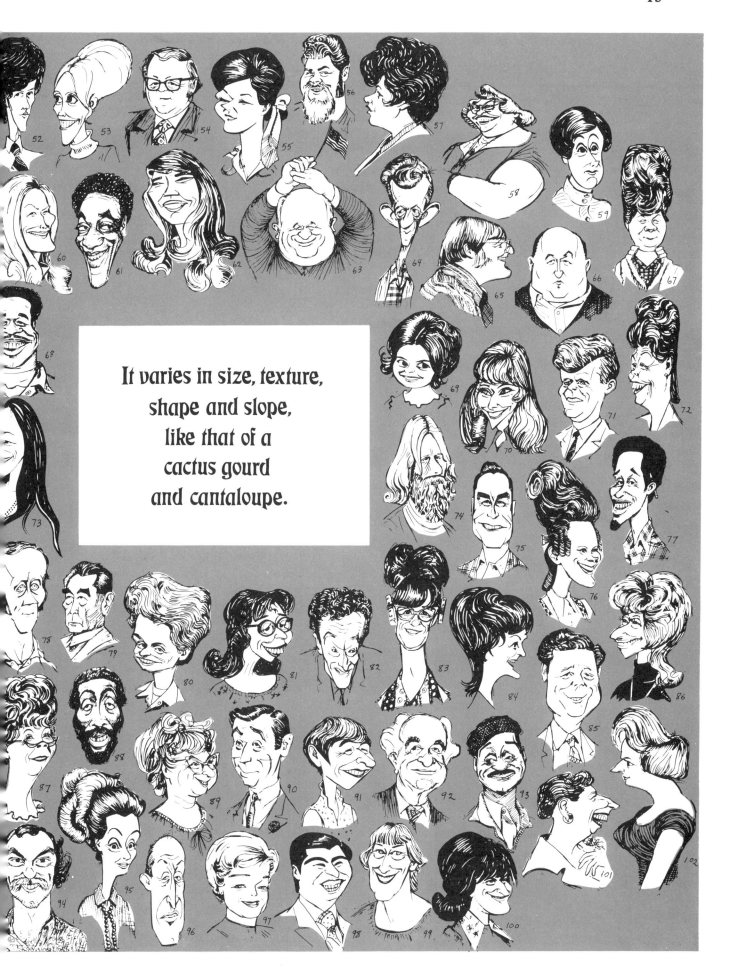

It varies in size, texture,
shape and slope,
like that of a
cactus gourd
and cantaloupe.

15

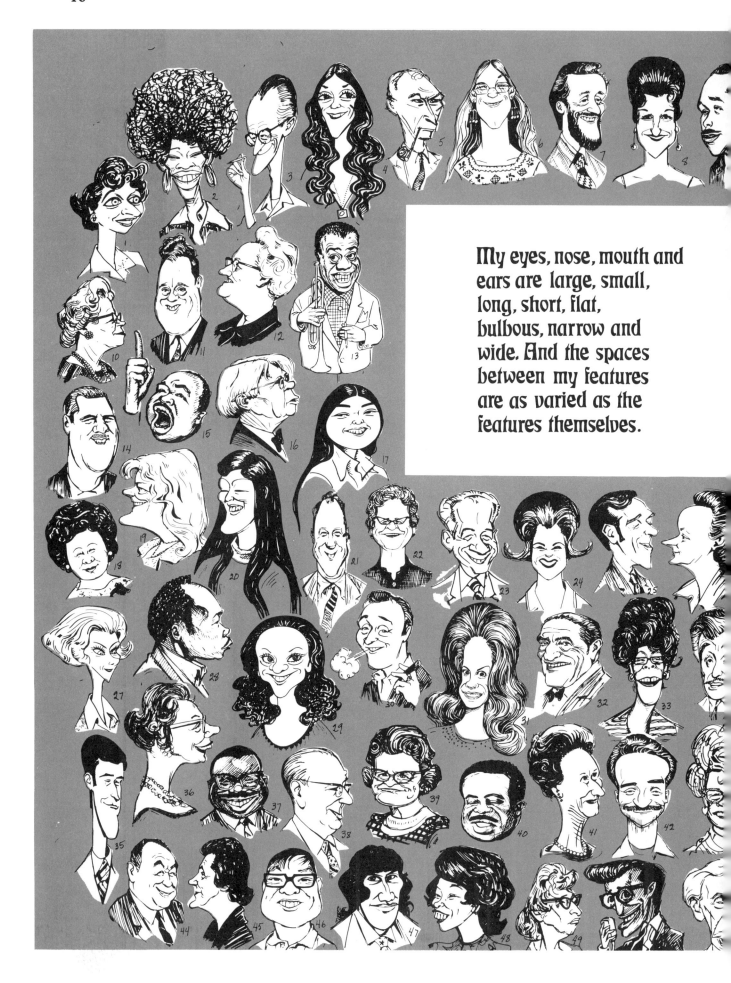

My eyes, nose, mouth and ears are large, small, long, short, flat, bulbous, narrow and wide. And the spaces between my features are as varied as the features themselves.

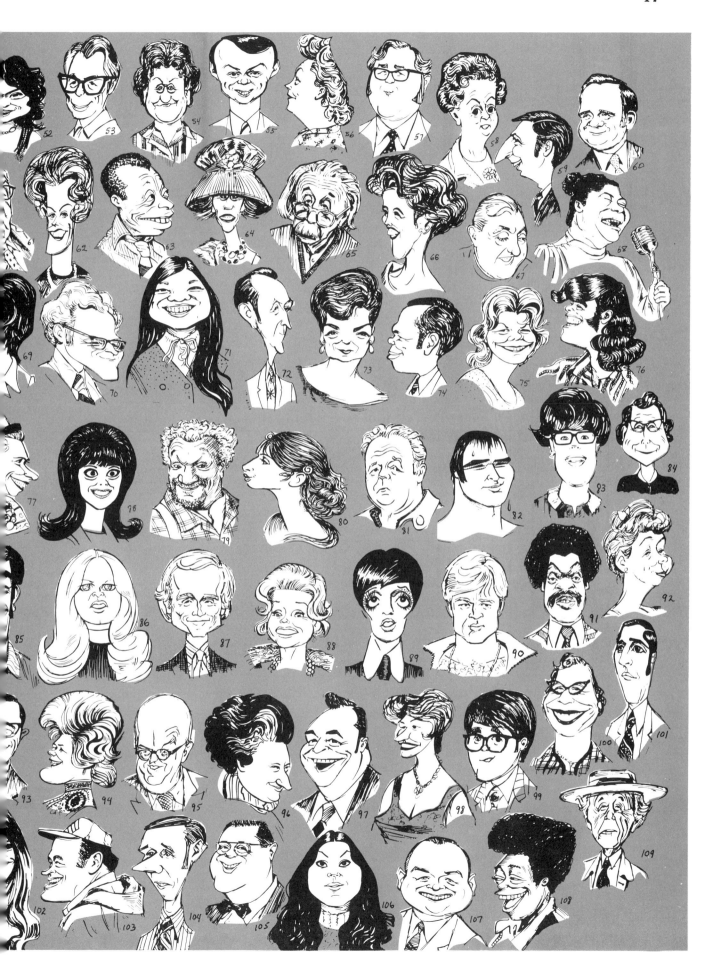

3

Practice by Drawing Comic Faces

It's time to start practicing—but without a model. If you are a beginner, be patient. Drawing real people comes later.

BEGINNING TO DRAW

To help the beginner get into the habit of drawing symmetrically, I have laid out a few symmetrically subdivided rectangles on this page, to be copied or traced onto another sheet. By drawing the features within the allotted spaces, the beginner can more easily control the symmetry of the face.

The comic faces on the next page were created in the same way—by my having drawn the rectangles with their subdivided lines first. Notice that the spaces between them are not the same as the spaces between the lines separating the In-betweener's features. Also observe that the smiling mouths are a little above the mouth lines. I'll explain why later.

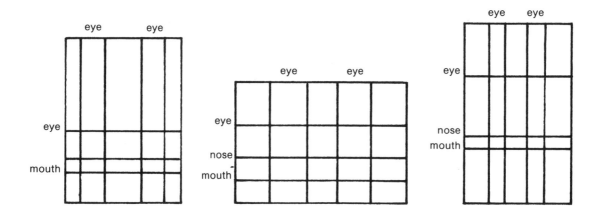

THE ADVANCED STUDENT

The diagrams for this exercise can be of help to the more advanced student, too—but for a different reason. I have found that even after detailing the codification of my "In-betweener" formula, many of my students who have had previous art training are quite timid about exaggerating.

The shape of the rectangles and their subdivisions in this exercise were drawn differently from the In-betweener's construction so that the advanced but inhibited student may readily see how possible it is to draw a face with extreme proportions and at the same time give it an appearance of plausibility.

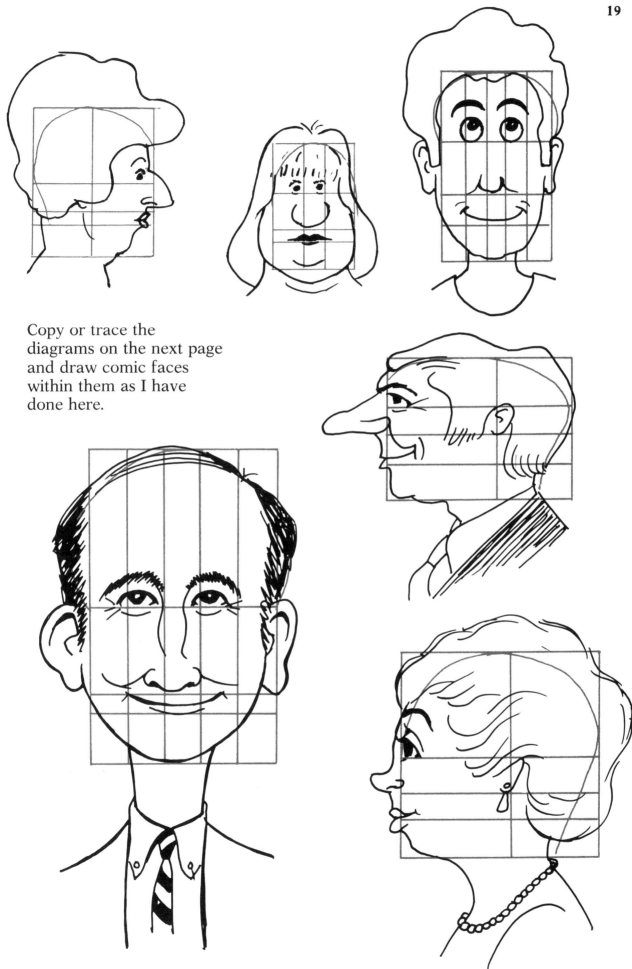

Copy or trace the diagrams on the next page and draw comic faces within them as I have done here.

20

Study the
examples of hair
style on the
preceding pages
and the examples
of facial features
on pages 22
through 25
before beginning
this exercise.

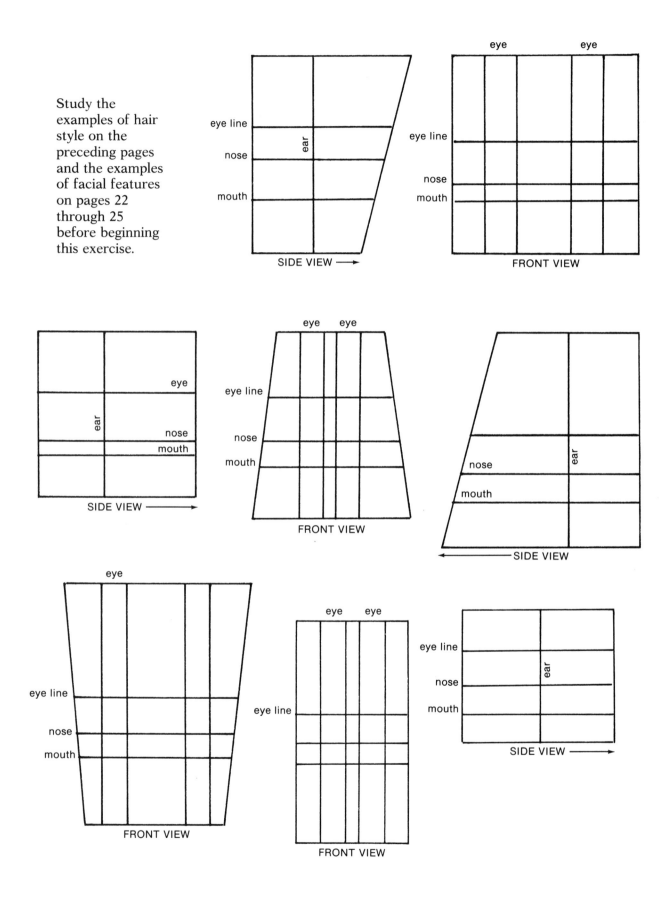

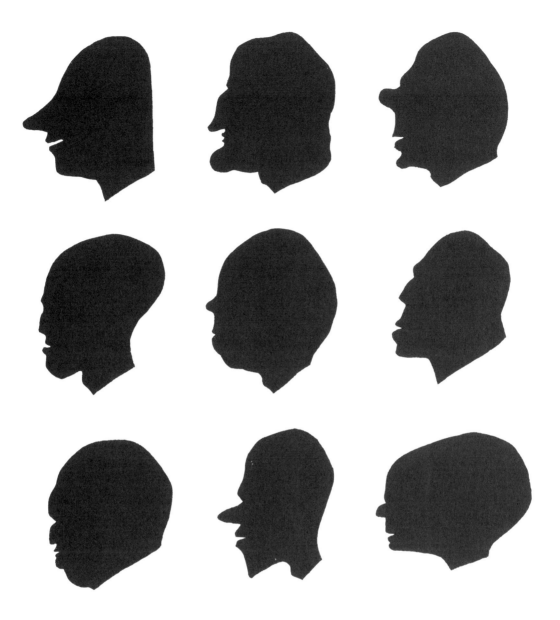

The whole trick to becoming a top-notch caricaturist is to develop a keen awareness of the differences among people's physical constructions. I have to keep harping on this because it is only by recognizing these differences that you will be able to exaggerate your subject's features correctly. When you are drawing someone, it is important to consciously realize that you are seeing the nose as tilted one way or the other, turned up or down, or that the nostrils are large, small, wide, or narrow. It is important to recognize whether you are seeing your subject's mouth as being large or small, with full lips or thin lips. And when he laughs, do you see large teeth or small teeth? Are they close together or far apart? Do the gums show? If so, how much? And how about the ears—are they large, small, round, broad, narrow, pointy, thick, or thin?

As you look, it is of utmost importance for you to realize all the peculiarities of what you are seeing. Let's take a close-up scrutiny of a few distinguishing types of features that some of us are endowed with. Maybe that will help.

22

Our EYES

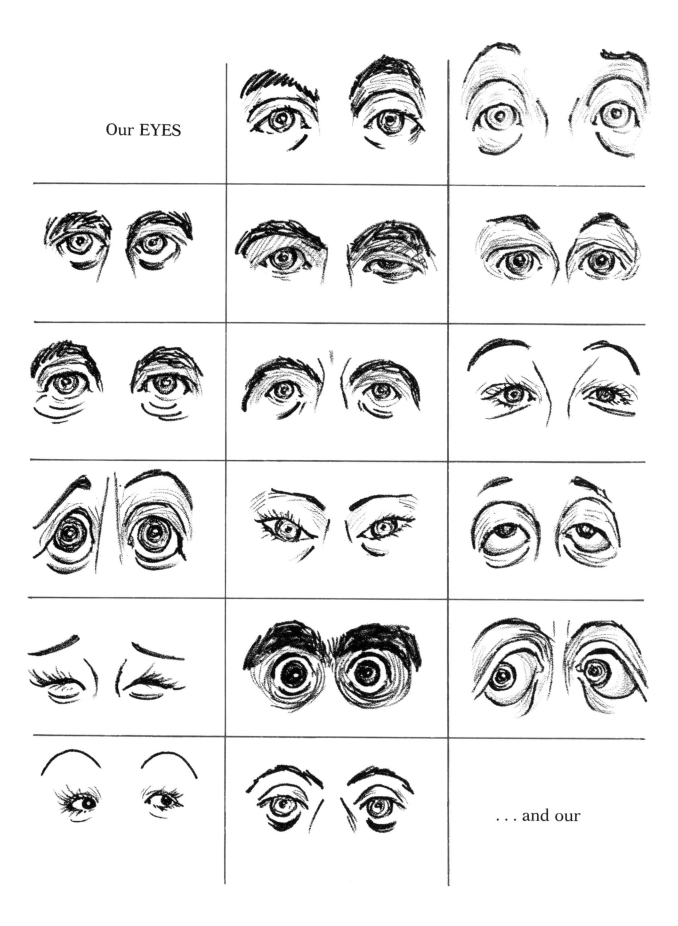

. . . and our

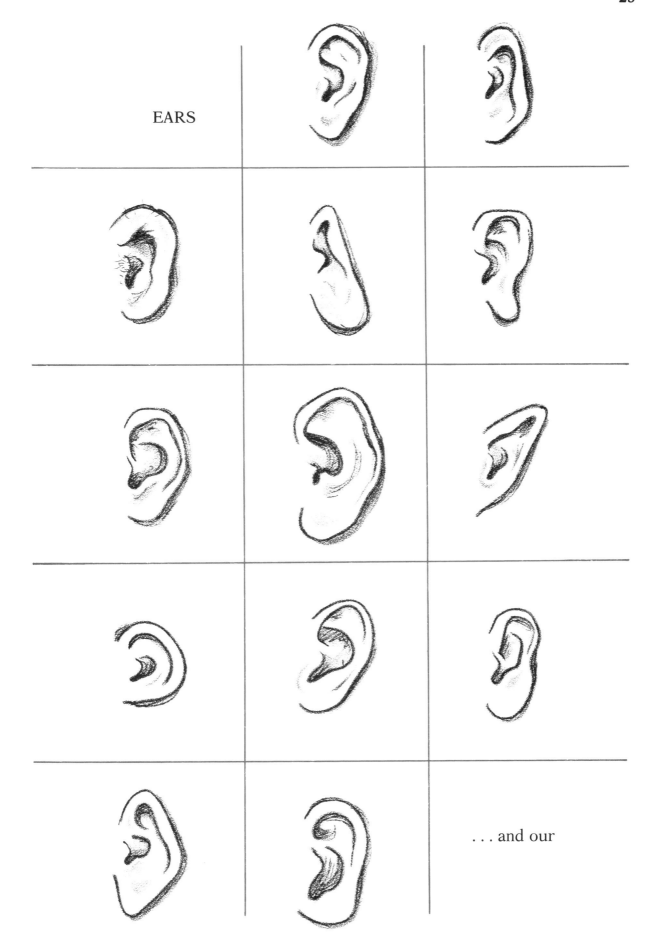

EARS

. . . and our

NOSES

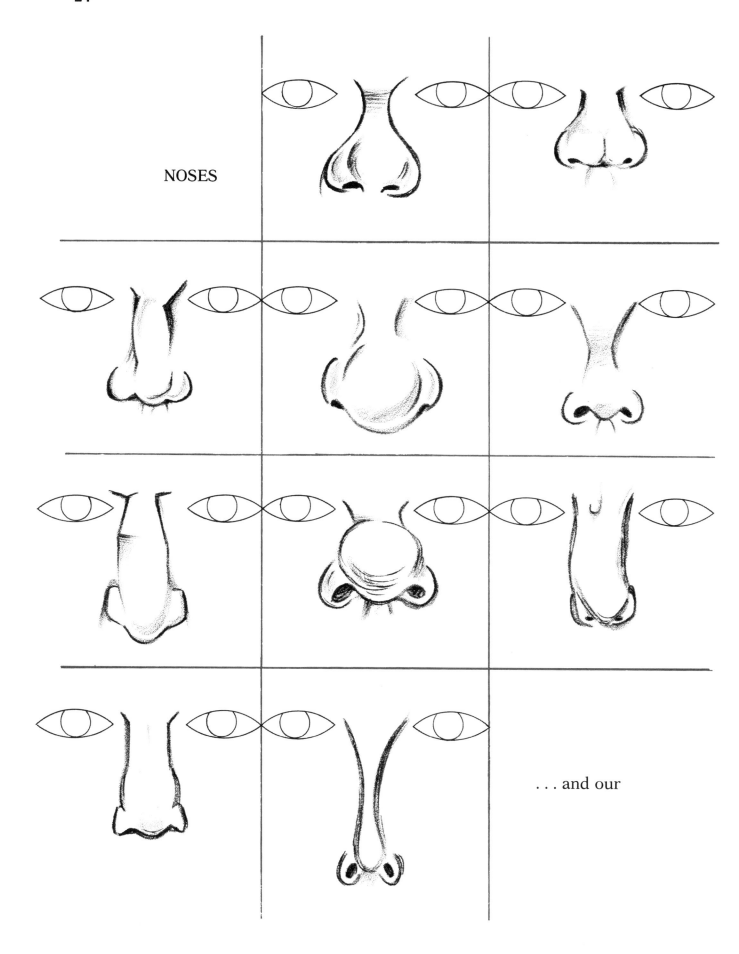

. . . and our

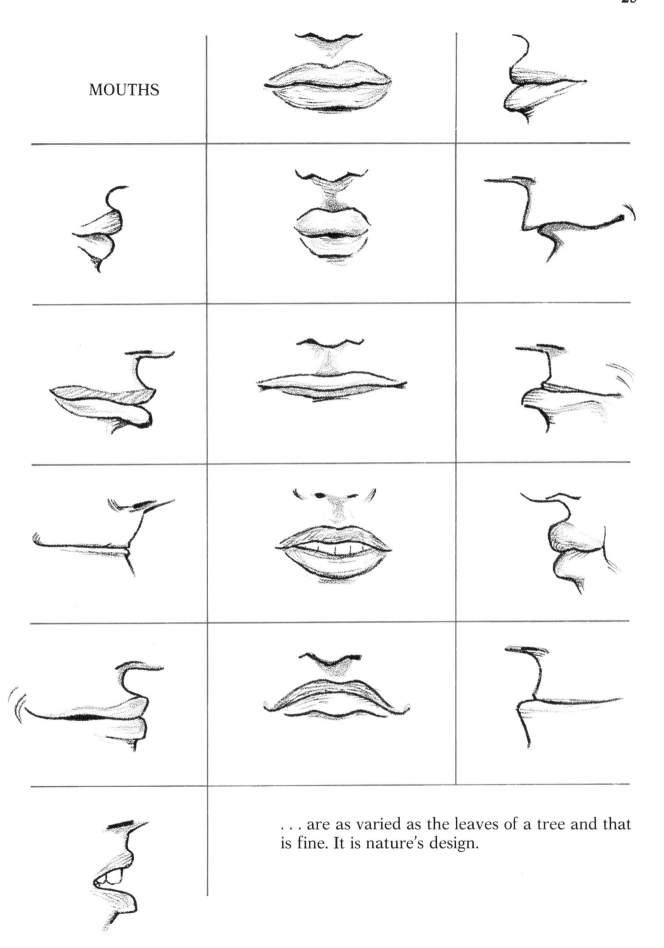

MOUTHS

. . . are as varied as the leaves of a tree and that is fine. It is nature's design.

Now that you've begun to sharpen your awareness of people's differences and have practiced drawing comic faces within subdivided rectangles, let's see how my formula works on real people.

The photograph of my friend pictured here and of my friends on the next few pages are superimposed with construction lines subdividing the spaces between their features.

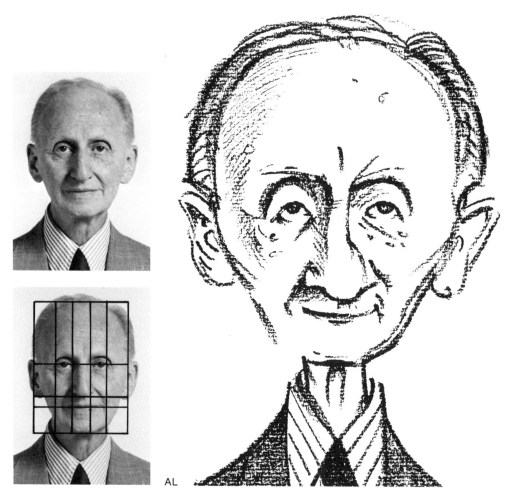

AL

You will notice that the construction lines are not the same as the In-betweener's. Naturally they're not the same, because my friends don't look like the In-betweener. Review pages 5 through 9 and you will understand how I was able to caricature my friends by comparing their features with the In-Betweener's features. This method of analyzing a person's photograph is an excellent way to learn to caricature. Try it. Draw construction lines lightly over newspaper and magazine photographs of people as a guide, then draw them.

The method should be considered as a *preliminary* step for learning. That's all it is. You should not become dependent on it later or your drawings will look stilted. With the exception of the type of artistic caricaturing requiring painstaking deliberation (to be explained later) your caricatures should eventually be drawn with spontaneous ease.

Let's begin analyzing the facial constructions of my friends. My descriptions of them are in contrast to the In-betweener. For example, when I describe a head as being narrower or wider, I mean in contrast to the In-betweener's head; when I say a subject's eyes are closer together or farther apart, I mean in contrast to the In-betweener's eyes. I sometimes refer to a feature having a specific appearance because of the way another feature of the subject is constructed. This will clarify itself for you in my chapter on Relativity Part 2.

Take a good look at Al on the preceding page. I drew his head wider than it really is because it is wider than the In-betweener's head. The spaces between the In-betweener's features are equal—not so with Al. The spaces between the outer edge of his eyes and the sides of his head are greater than the width of his eyes and the spaces between them. The space between Al's nose and mouth is less than the space between the In-betweener's nose and mouth so I exaggerated it by narrowing that space.

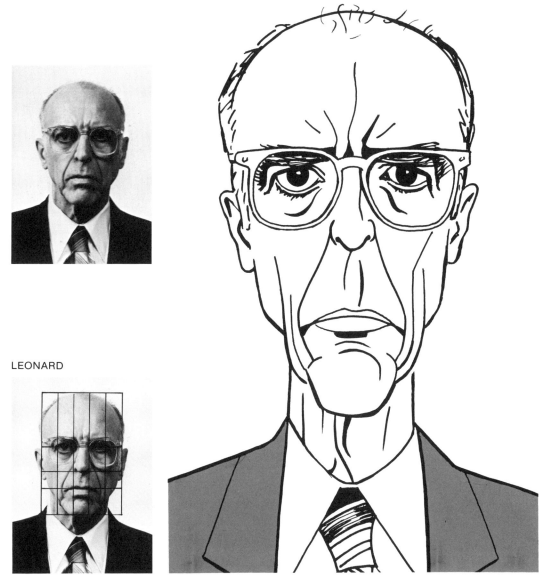

LEONARD

The width of Leonard's head is the same as the In-betweener's but it looks narrower because it tapers in toward the chin. The vertical spaces between his features are equal but they appear off a bit because his head is turned slightly to his left.

The greatest departure of his face from that of the In-betweener is in respect to the horizontal measurements of his features: His eyes are larger and higher than the In-betweener's. His high-bridged nose is shorter and much higher than the In-betweener's nose. This produces a tremendous space between his nose and his mouth.

 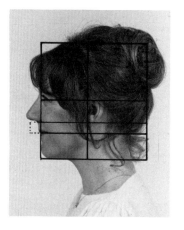

SUSAN

The protrusion of the In-betweener's nose is equal to the space between the bottom of the nose and the mouth. Susan's nose is longer, so I exaggerated this length in this caricature.

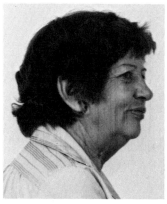 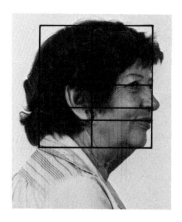

MARTHA

Martha's ear is larger than the space between her eyes and her mouth, and whereas the In-betweener's lips do not protrude, Martha's lips do—these differences are played up in her caricature.

 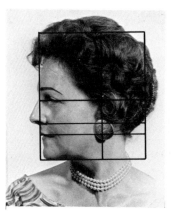

MARIAN

The lower third of Marian's face recedes as compared to the lower third of the In-betweener's face.

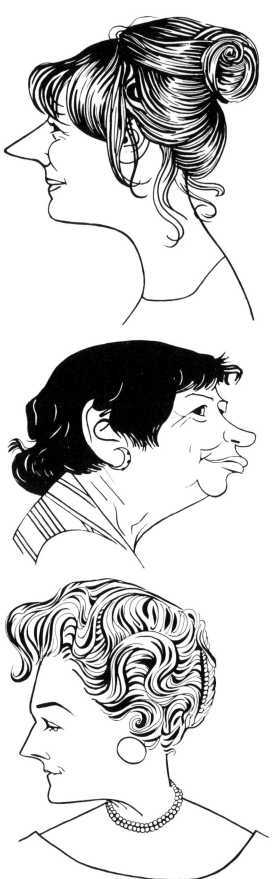

 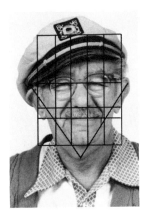

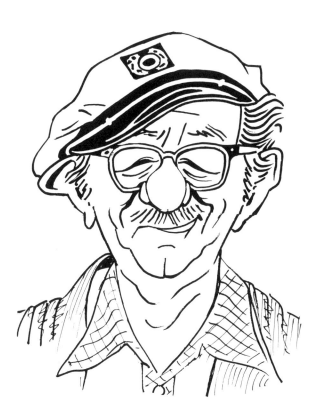

MEYER

Meyer's head is very broad at the eye line. It tapers in toward the chin. His eyes appear to be close together when compared to the space between the outer edge of his eyes and the sides of his head.

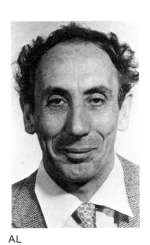 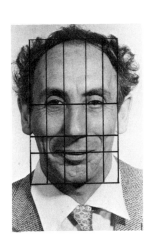

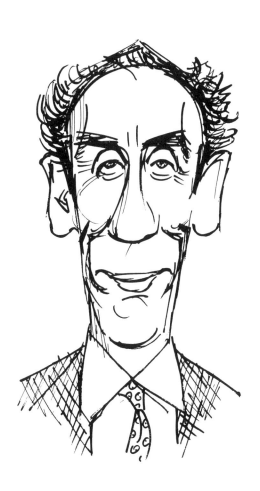

AL

Al Francois' head is very narrow. The space between his eyes and the top of his head is relatively small, and the space between his nose and his mouth is large.

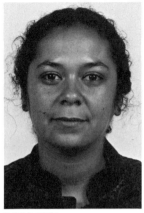 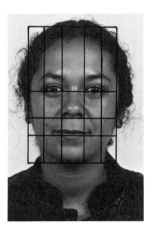

KATHLEEN

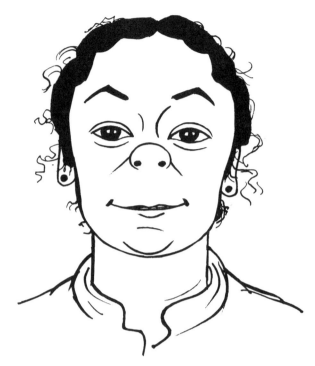

Kathleen's head at the eye line is wide and the fullness of her jowls makes her head look even wider. The space between her nose and her mouth is more than one-half the space between her mouth and the bottom of her chin; all these relationships are stressed in caricature.

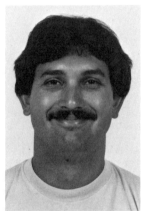 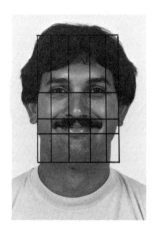

VINCENT

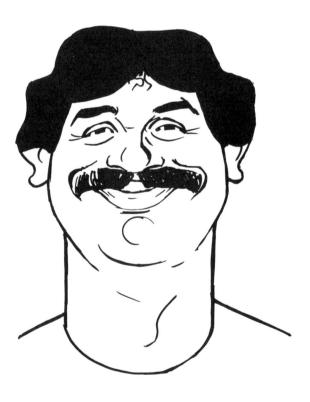

Vince has a similarly shaped head. Since his smile puffs his cheeks out, his head looks rounder. (Note the considerable space between his eyes and the fact that his smile widens his nose. I'll explain that effect in more detail later.)

 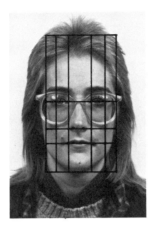

SUSAN

Susan's face is narrower than the In-between-er's—so is her nose. Her jawbones are broader than his.

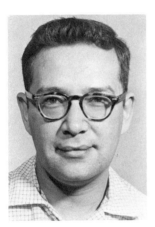 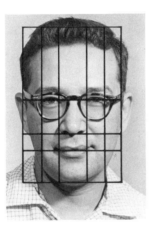

RICHARD

Richard's head at the eye line is the same width as the In-betweener's. It seems broader because of the fullness of his cheeks and jowls.

Is it necessary to describe his interesting lips?

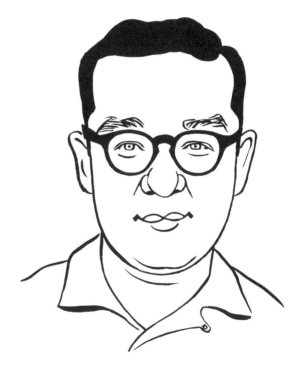

Subdivided construction lines superimposing photo portraits are marvelous aids for the beginning caricaturist, but as previously stated, there comes a time when you should not need to draw them: The formula should be lodged in your mind so deeply that you will use it unconsciously.

We are now ready to study Relativity Part 2. Its importance to the art of caricaturing is equal to Relativity Part 1 which involves using the In-betweener as a frame of reference.

4

Relativity Part 2:
The Relationship of Things
to Their Surrounding and Abutting Elements

Since caricaturing may be only one of your graphic art interests and since my conception of the theory of relativity is applicable to the other arts, I think it is appropriate to explain it with abstract shapes.

Here we have a triangle set alone—independent of anything else. With nothing to compare it, there is nothing to give it relative distinction.

However, if we accompany it with a structure entirely different, the imaginative artist can exaggerate their contrasting differences.

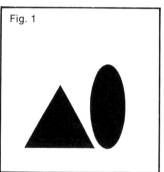

To illustrate: Figures 1 and 2 show the same triangle standing next to an oval. In one square the oval stands vertically. In the other it is horizontal.

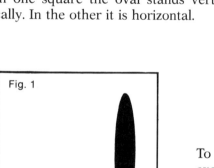

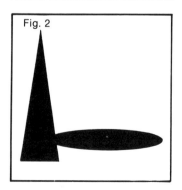

To emphasize their contrasting shapes I have redrawn them exaggeratedly. By flattening the triangle and lengthening the oval of Figure 1 and by lengthening the triangle and flattening the oval of Figure 2, their relative differences are dramatically pronounced.

In its application to the art of caricaturing, the size and shape of a person's features may be exaggerated, not only by comparing them with the In-betweener's features but by comparing them with the size, shape, and location of your subject's other features. For example, you may decide to draw your subject's eyes small, not necessarily because they are smaller than the In-betweener's but because your subject's other features are large by comparison. Or you might choose to draw a particular feature round, not because it is rounder than the In-betweener's but because the other features are angular by comparison. The application of this approach will clarify itself as we continue.

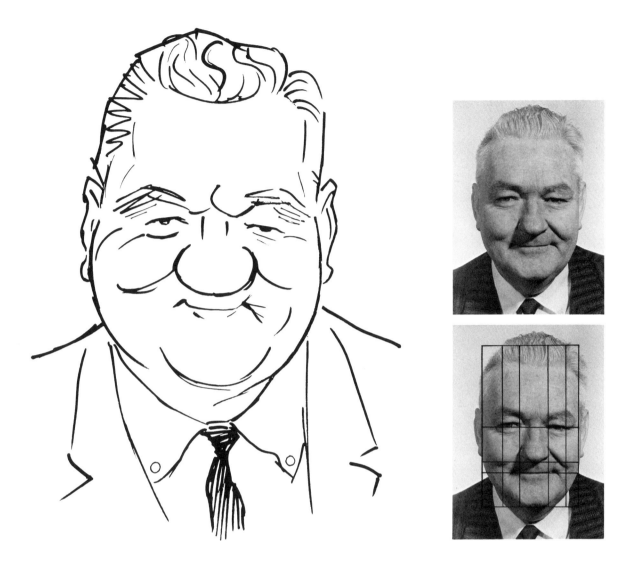

Here's Al. Al is a perfect example of a person whose features can be exaggerated by comparing them, not with the In-betweener's features, but with the size, shape, and location of each other. Notice that his mouth is not smaller than the In-betweener's but I drew it smaller because it appears that way due to the fullness of his cheeks and the width of his nose. By comparing Al's eyes with his other features, I found it necessary to draw them smaller. And the roundness of his face made the top of his head appear narrower—so, naturally, I drew it that way.

Now turn back to page 31. Susan's face is narrower than the In-betweener's but it appears even narrower because the lens of her spectacles seem to contract the width of her face within the spectacles. Though her mouth is where the In-betweener's mouth is relative to the rest of her features—1/3 down between the nose and the bottom of the chin—I elongated her chin in order to emphasize the narrowness of her head.

Take a good look at Marian's massive coiffure on page 28. It gives the impression that the space between her eyeline and the top of her head is greater than that of the In-betweener's. It may not be but I drew it larger because of its resultant impression.

See if you can figure out how I applied relativity's two parts to all caricatures in this book.

NOW LET'S PROCEED WITHOUT GUIDELINES

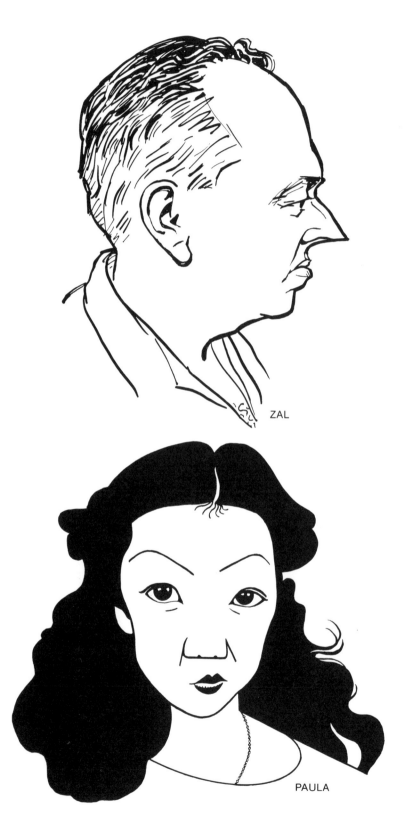

ZAL

PAULA

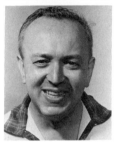

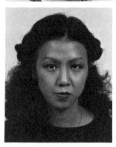

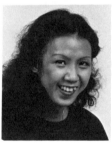

These caricatures and all those following are printed with their respective photographs devoid of superimposed guide lines. Exercise your knowledge of what you have learned so far by figuring out why I have exaggerated Zal's and Paula's features and all my other friends in this book the way I did.

STRETCH YOUR IMAGINATION

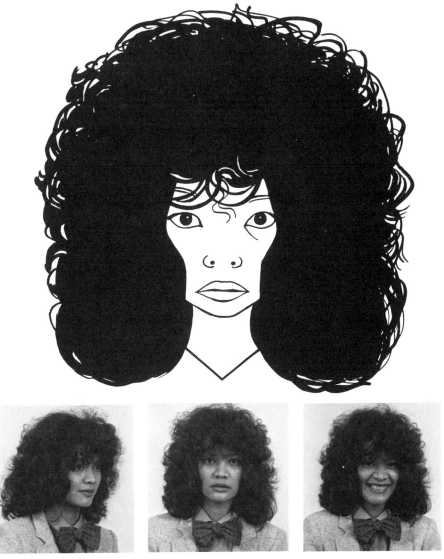

CYNTHIA

What you see may not necessarily be what actually is. Therefore you may exaggerate the *impression* of what you see rather than its actuality. (I'll talk more about impressionistic caricatures in Chapter 9.) I'm bringing up the subject now because it is correlated with your utilization of Relativity Part 2, the art of caricaturing a face by comparing the sizes and shapes of its features with each other and exaggerating them accordingly.

A perfect example of this approach is the effect Cynthia's hairdo had on me in the way I drew her. It seemed to me that her face assumed a bizarre design by the way her hair was set. The design is evident from the front—that's why I chose to draw her from the front. As you can see from the other photographs, she has a lovely face. Her mouth is not particularly large but because her hair drapes in close to her mouth and covers her jaws, viewed from the front her mouth appears larger than it is. The fullness of her hair casts a shadow on the sides of her face giving the impression her face is extraordinarily narrow and angular. It isn't—but I think I've retained her likeness in spite of having drawn it that way.

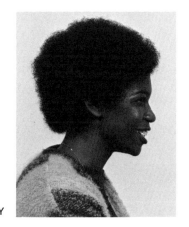

RUBY

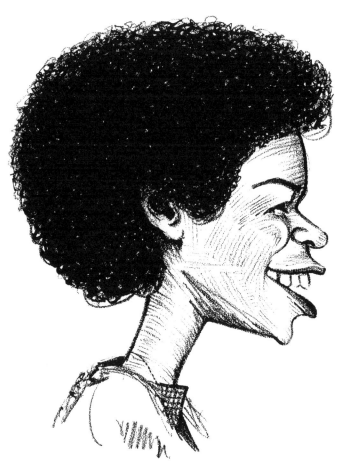

Impressions are highly personal. One individual's impression of a thing can be entirely different from another's. And a person's impression of a thing can change with time—thus a caricaturist's interpretation of a subject might be different on two different occasions.

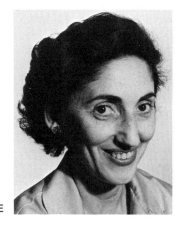

ROCHELLE

See how different my interpretation of Rochelle and Ruby is on page 120.

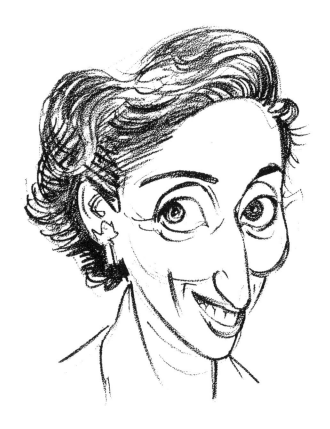

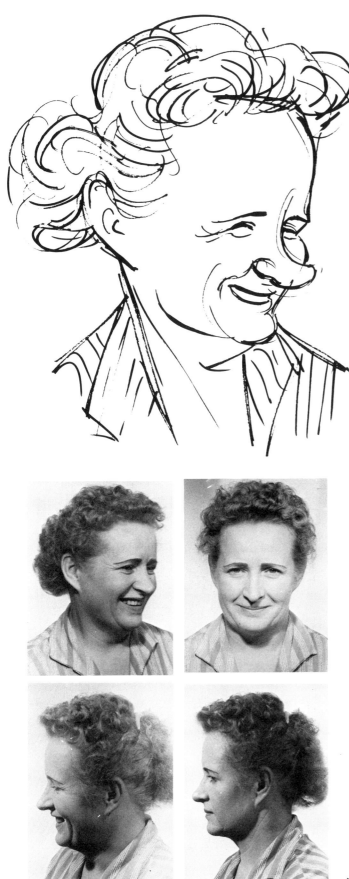

I used different pens on each of these. Different pens, different mood, different effect.

Regarding the front view: Natalie tilted her head down as the photograph was taken. It gives the impression that her nose turns down. The upsweep of her nose is enjoyably caricaturable but I think the squarish look to her face is equally interesting.

NATALIE

Some people lend themselves better to caricature than others. In spite of Anthony's good looks, he was a joy for me to draw.

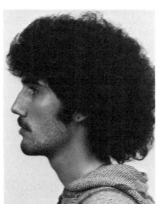

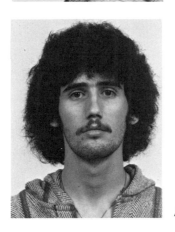

ANTHONY

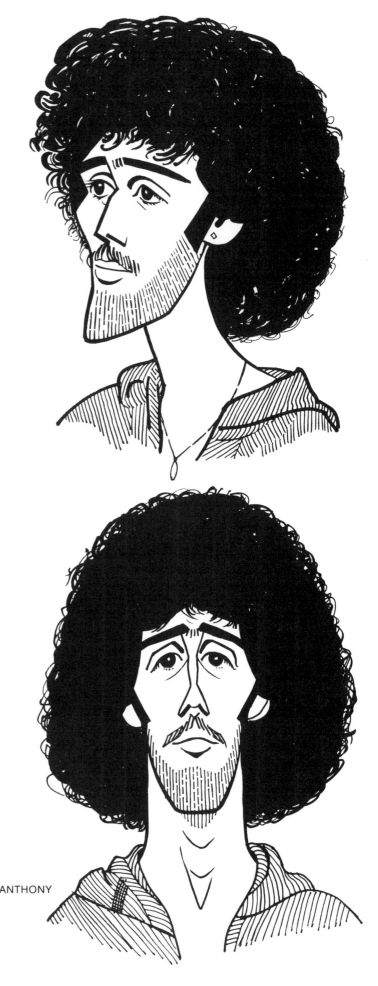

THINK THREE-DIMENSIONALLY

Thus far we have analyzed the face and cranial construction from only two dimensions: height and width. But the human head has depth. By depth I mean that its muscles, bones, and flesh protrude and recede. Therefore, think three-dimensionally and exaggerate the protrusions and indentures. The drawings shown here are virtually architectural constructions. I prepared them as an exercise. Their planes are based on my imagination and experience rather than human anatomical measurements. It wouldn't hurt you to draw a few imaginary faces of your own in this manner. It requires a little understanding of perspective (that's an art in itself). Start practicing on inanimate objects—a ball, a can, a bottle, a box—anything. The exercise will help you see and draw the subtle planes and complexities in your subject's face. The planes are more noticeable from views other than direct front or side views, and in most cases are more interesting when drawn that way.

Look at the drawing of Andrew Mellon on page 133. Scott Johnson was a master at three-dimensional drawing. Whether obvious or not, all the drawings in this book are three-dimensional.

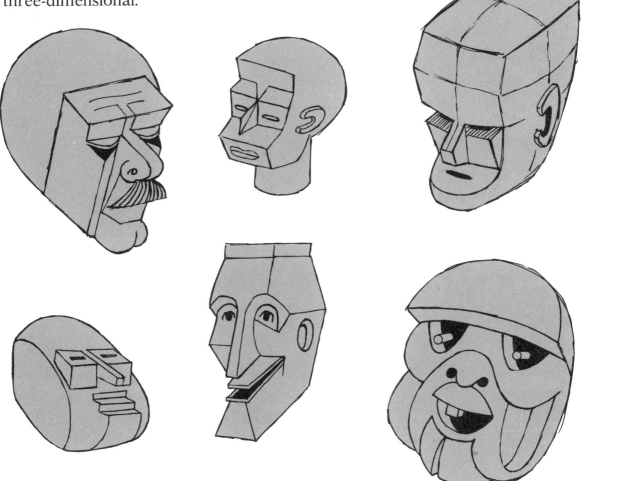

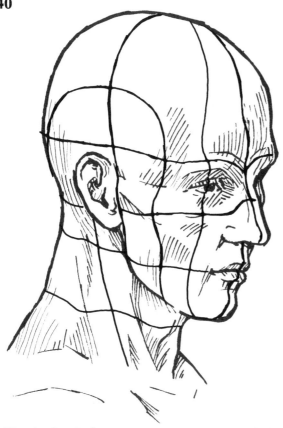

Here's the In-betweener again. I put a little more character into him this time so that you can more readily see the planes of his face.

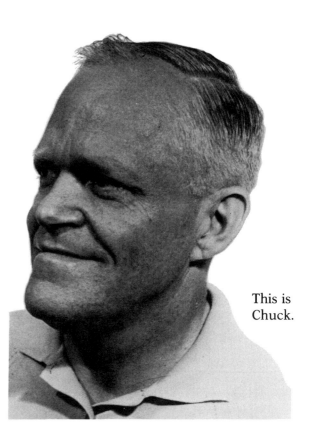

This is Chuck.

Chuck can afford to look defiantly at the In-betweener because his face is more interesting. It's interesting because it has depth.

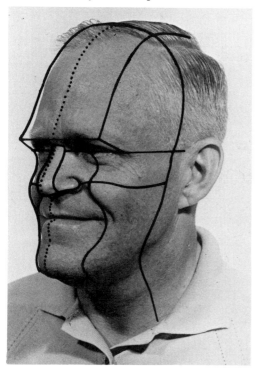

The human head has dozens of bones and muscles. There's no need to know all of them nor to know every detail about those you do know. But you should know enough about the cranium so that, thinking three-dimensionally, you can give your

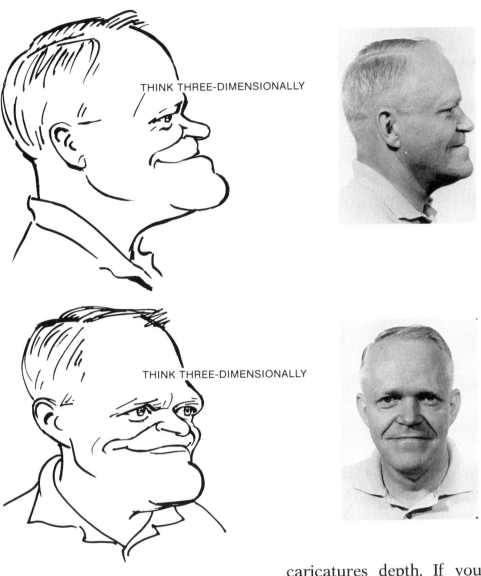

THINK THREE-DIMENSIONALLY

THINK THREE-DIMENSIONALLY

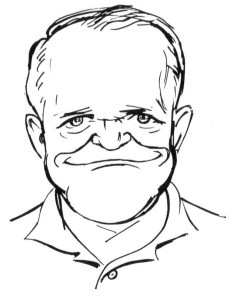

caricatures depth. If your subject's cheekbones protrude, make sure your drawing shows them protruding. If there's a deep indenture under the cheekbones, make sure your drawing shows it. You should be able to emphasize every protrusion and indenture on your subject's face, no matter how subtle. This does not mean you need necessarily always draw this way, for the style of drawing you may ultimately perfect may be very simple. But while you are studying, you should learn to put depth into your drawings.

THINK THREE-
DIMENSIONALLY

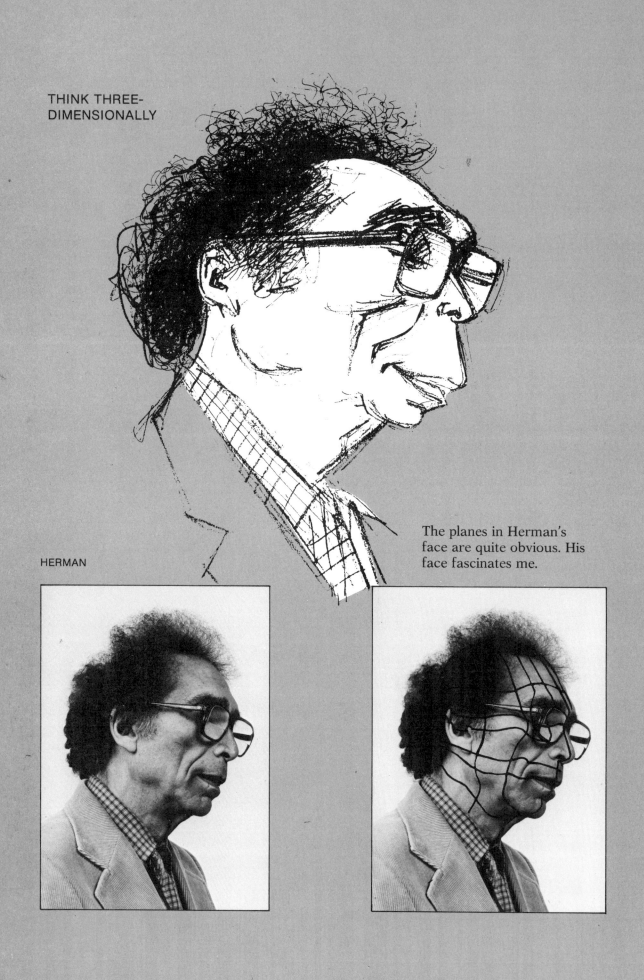

The planes in Herman's
face are quite obvious. His
face fascinates me.

HERMAN

NO TWO SIDES OF THE FACE ARE THE SAME

Keep that in mind! If you notice it in your subject, *play it up.*

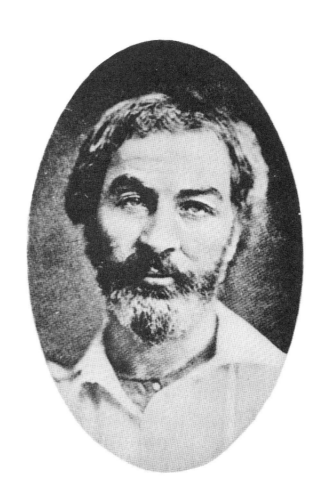

This is Walt Whitman. His was an extreme example of such a face. In spite of the shadows, we can see that his nose was twisted to his right and his right nostril was higher than his left. His right eyebrow turned up, there were a couple of creases on the right side of his forehead, and his eyes looked like they could have belonged to two different people.

I've made duplicates of Mr. Whitman's photo, cut them apart, and pasted each half on opposite sides so that you can see how different he would have looked if both sides were the same.

So to repeat, no two sides of a face are the same. Look for it in your subject and if it's extreme, play it up. By that I mean exaggerate the difference to the hilt.

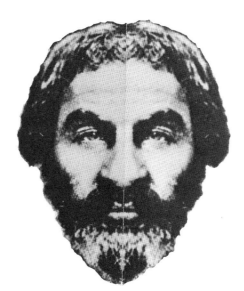

Two right sides

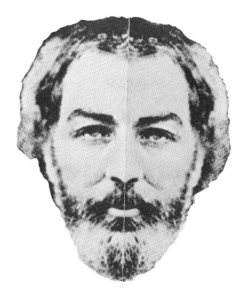

Two left sides

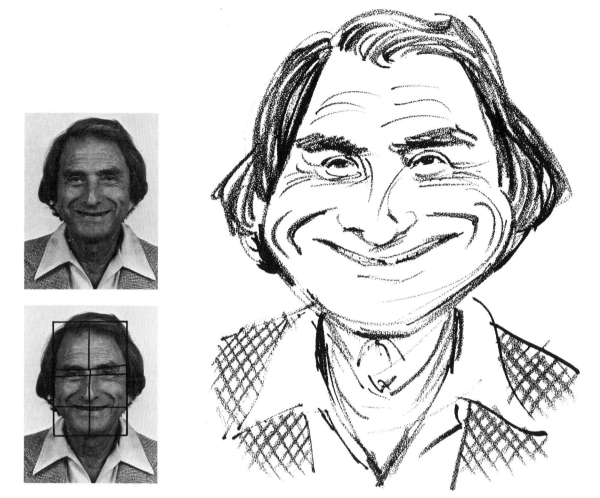

This is Lee. The lines running down and across his face leave no doubt that the sides of his face are different.

Incidentally, I scribbled Lee's face, as I have a few others for this book, with as much love as I have for my friends whom I drew with meticulous care. My intent is to show you a variety of styles and techniques. No particular one is necessarily better than the other. A recognizable likeness is what really matters. (I've portrayed Lee differently elsewhere in the book.)

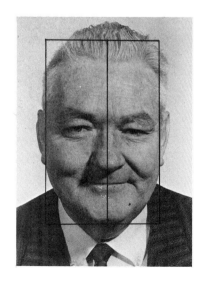

Here's Al again. His photograph, partially analyzed for caricaturing, appears on page 33 with his caricature. He warrants another scrutiny. The vertical line running down the center of his face is closer to his left. Under ordinary circumstances, this would indicate he is turned slightly to his left.

But he isn't. Both sides of his nose are seen equally—and so are his ears. If he were turned slightly, one side would show more than the other. The vertical line down the center of his face reveals the fact that the right side of his face is wider than his left. The horizontal line shows that one eye is higher than the other.

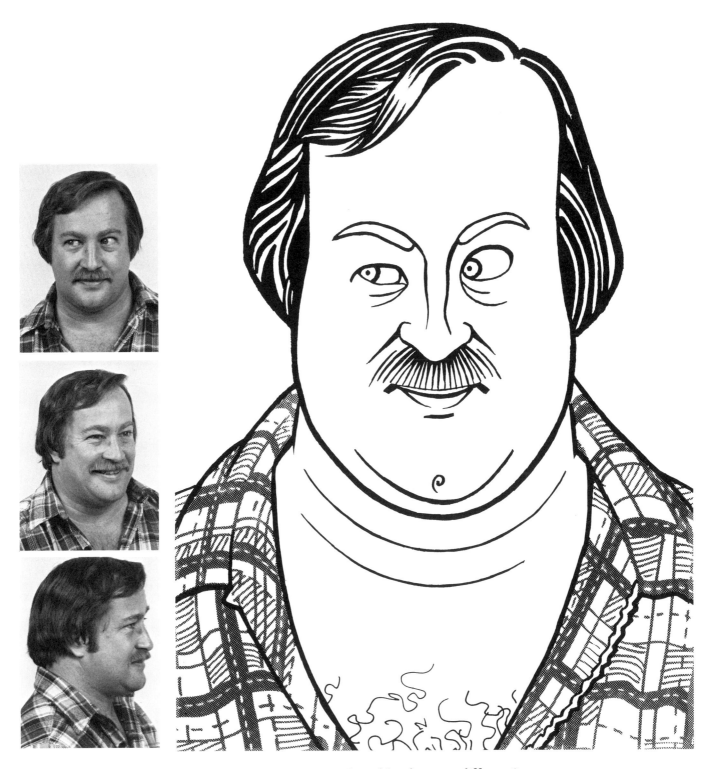

This is Bill. Is there a need to describe the way the sides of his face are different?

46

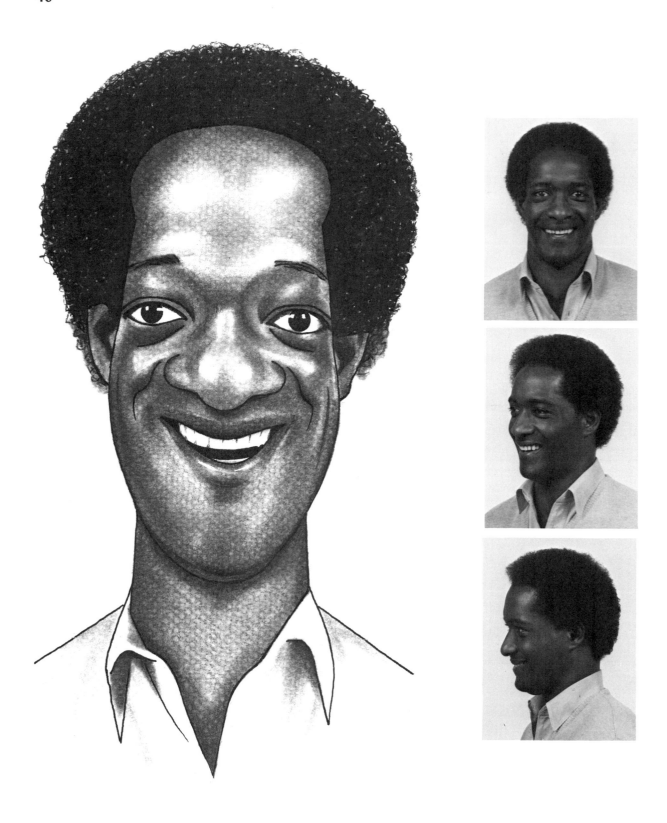

Sandy was drawn with a Wolf carbon pencil and shaded with a paper stump. The pebbly effect is due to the grain of the paper I drew it on.

Make Them Laugh!

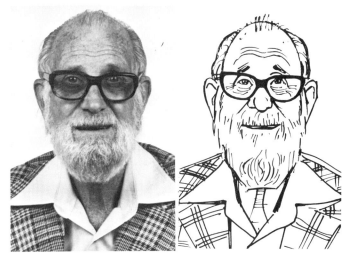

HECTOR

Unless your subject has a sober expression so unique or so humorous that you just can't resist drawing it that way, try to make him or her laugh. Laughter is infectious. If your drawing is laughing, the people looking at it will laugh and your subject will like it better. Keep in mind that the mouth is not all that laughs. The eyes, the lines around the eyes, the cheeks, and all the other features have a good time. And their enjoyable antics are as varied as their bone and muscle construction.

The same facial changes occur when a person smiles, but not quite as much.

Turn the page and see what happened to my serious friends shown here when they laughed.

Incidentally, my friends on the preceding pages were portrayed with bland expressions for the sole purpose of showing you the proportions of their features compared to the In-betweener's blank face. I apologize for not sharing with you my knowledge of their charm while smiling and laughing.

BILL

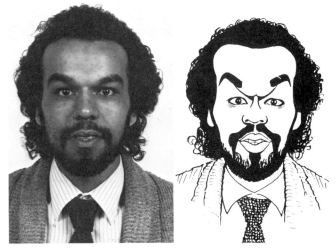

GREGORY

47

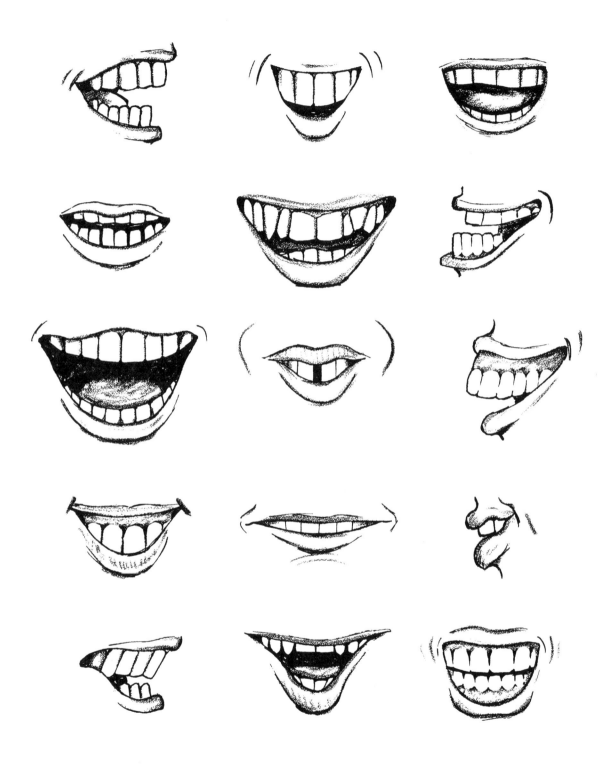

Notice the lower teeth are thinner than the uppers

If you wish to be true to the kind of caricaturing depicted here, don't attempt to draw a happy expression from a straight-faced photograph. Unless you know the person or have seen pictures of him or her smiling and laughing, you couldn't possibly do justice to the drawing.

There is another type of caricaturing, however, that might be suitable for such an attempt by the advanced student. When the required laughing photograph is not available, a competent, well-rounded artist can fake it. We'll get into that type of caricaturing soon. But for now, let's stick to a more realistic representation of people by exaggerating all the nuances of their smiles and laughs, including all of their expressions—subtle or otherwise.

All the In-betweener's features lift when he laughs. His cheeks go up, thus closing his eyes somewhat, and his mouth goes up. By that I mean his upper lip rises closer to his nose. His nostrils broaden and they also turn up.

Look in the mirror and laugh. See if your features do these things. Since none of us look exactly like the In-betweener, we all laugh differently. There are broad laughs and there are inhibited laughs, and the shapes and depth of the lines around our mouths vary. Some people reveal all of their upper teeth, some only a fraction, and others reveal none at all. The same is true of the lower teeth. And there are people who show neither their uppers nor lowers. Some people's gums like to take a peek at the world and you've no doubt seen a few tongues stick out of laughing mouths.

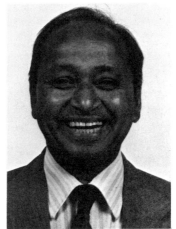
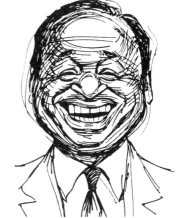

HECTOR

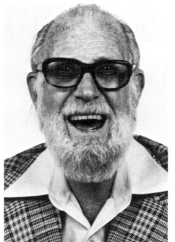
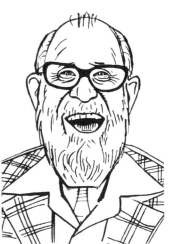

BILL

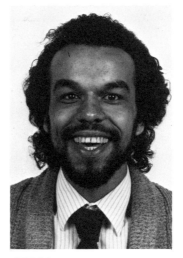
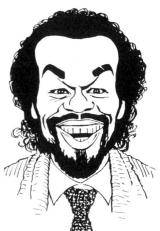

GREGORY

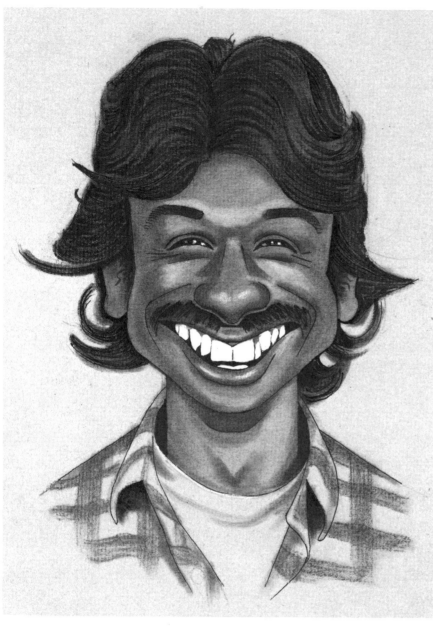

I used the same medium and method of shading Esrom's drawing as I did on the one of Sandy—page 46. I drew him on a tinted paper so that I could emphasize his teeth with white paint.

An inexperienced student might have chosen to draw him from the side because of the bump on his nose, but as you can see, much more of his personality shows from the front. His mouth, cheeks, nose, and eyes do all the things expected of a laughing face. His cheeks raise; his eyes close; his mouth lifts; his nostrils broaden and turn up.

Turn back to page 30. Vince's eyes are smiling— therefore his mouth is slightly above the In-betweener's mouth line. If Vince had laughed, his upper lip would have raised higher.

As explained before, these are the things that always happen to a smiling or laughing face—that is, *almost* always. There are exceptions. The next two pages comprise such exceptions.

ESROM

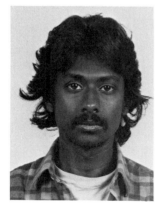
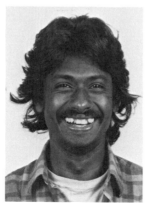
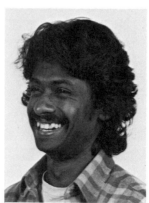
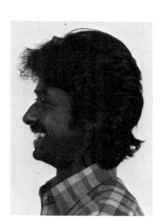

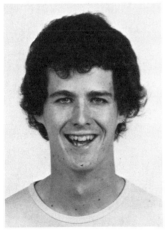

DAVID

David's eyes laughed only slightly when he laughed. Since the art of caricaturing includes the enlargement of that which is most and the minimization of that which is least, I deprived David's laughing caricature of the wee bit of enjoyment his eyes showed in his laughing photograph. As you can see, I gave both his drawings the same serious eyes.

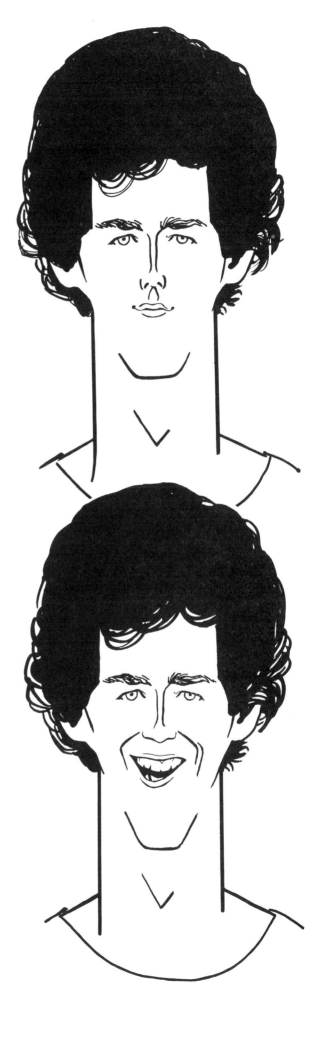

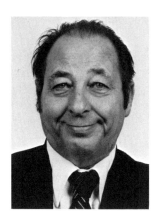

There's no doubt that Irv is laughing heartily. His head has flown back and his eyes have squinched up. But notice—his nostrils haven't flared very much and the space between his upper lip and nose is the same as when he didn't laugh.

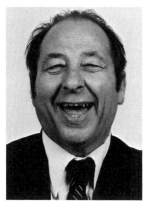

IRV

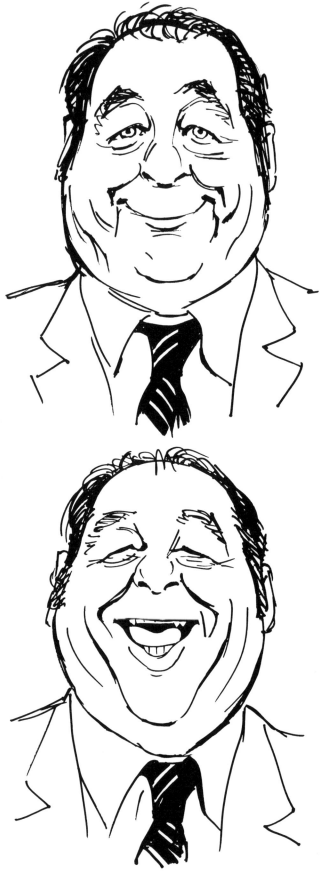

OUCH!
Can you see why
it's best to make
them laugh?

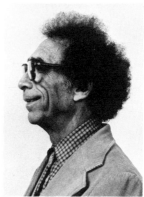

HERMAN

THREE APPROACHES TO THE SAME SUBJECT

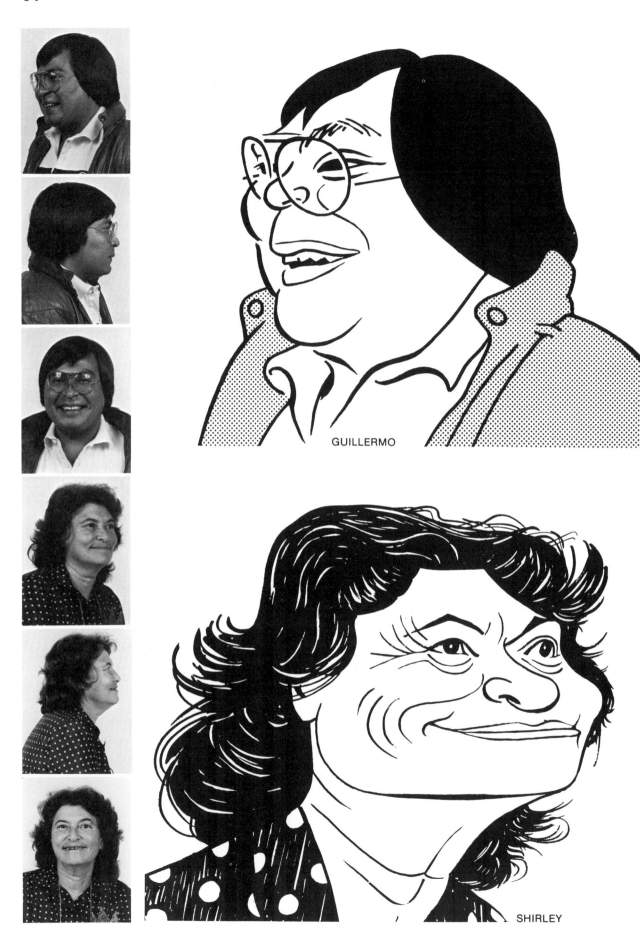

GUILLERMO

SHIRLEY

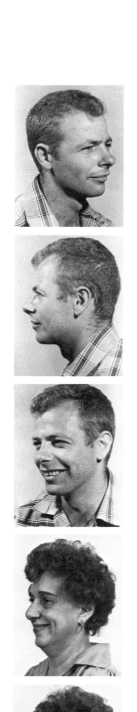

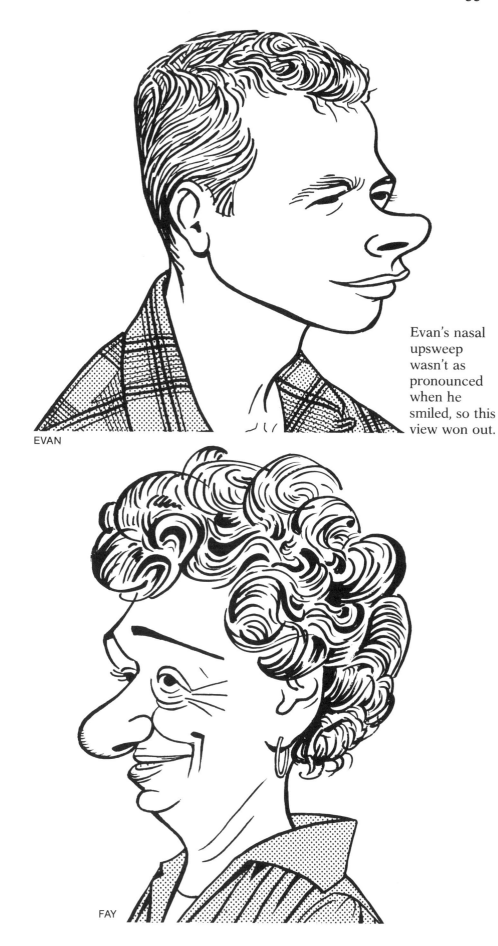

EVAN

Evan's nasal
upsweep
wasn't as
pronounced
when he
smiled, so this
view won out.

FAY

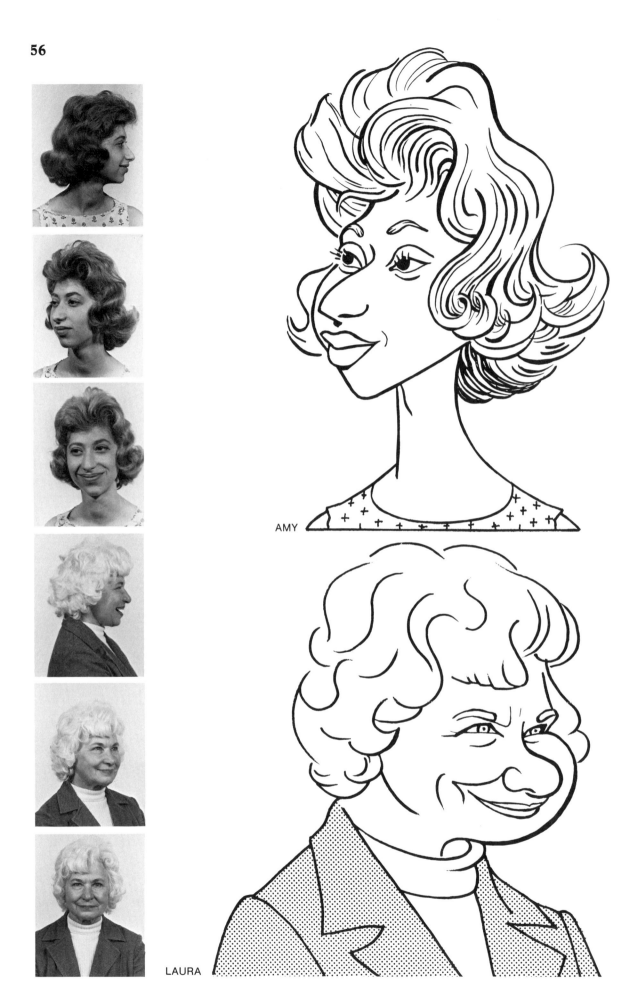

AMY

LAURA

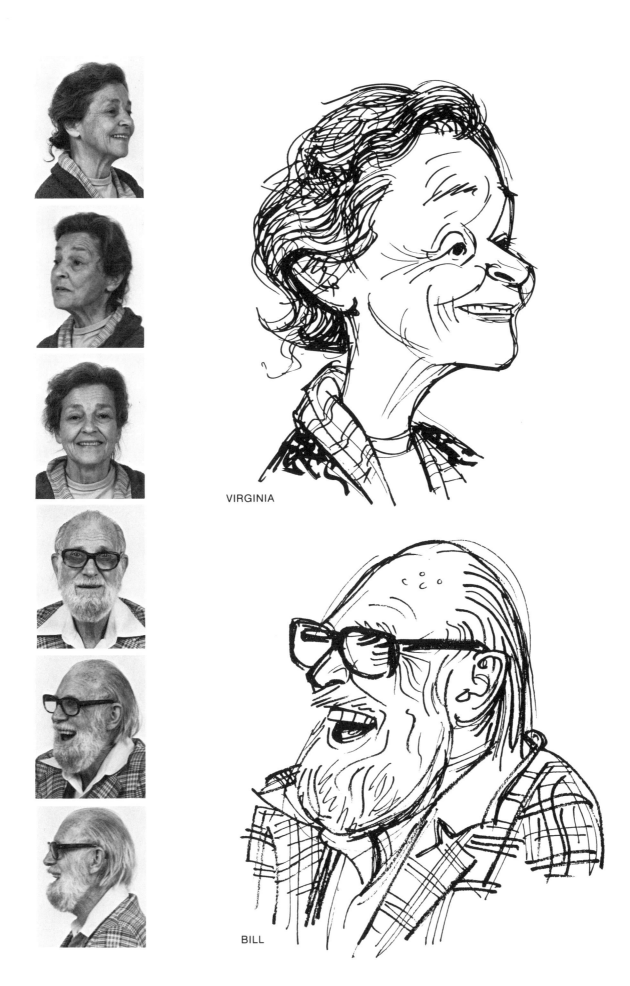

VIRGINIA

BILL

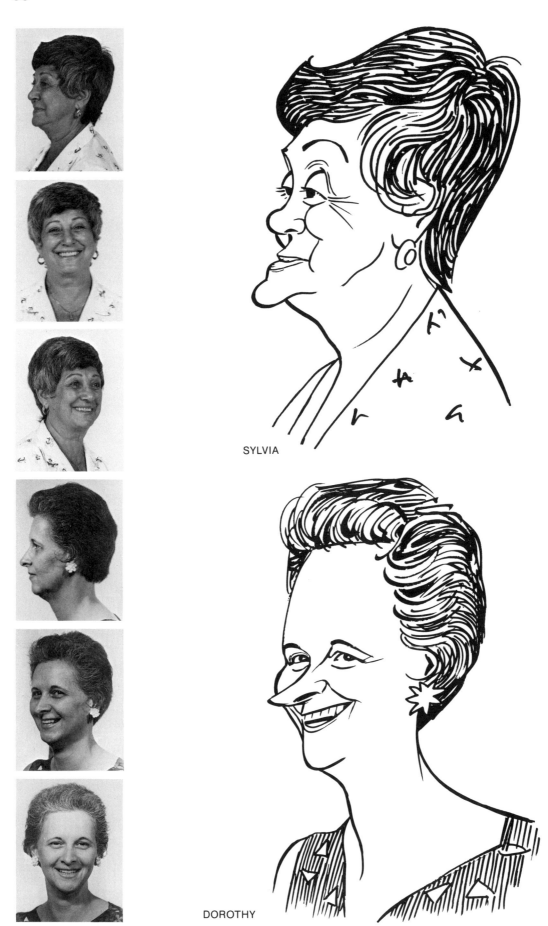

SYLVIA

DOROTHY

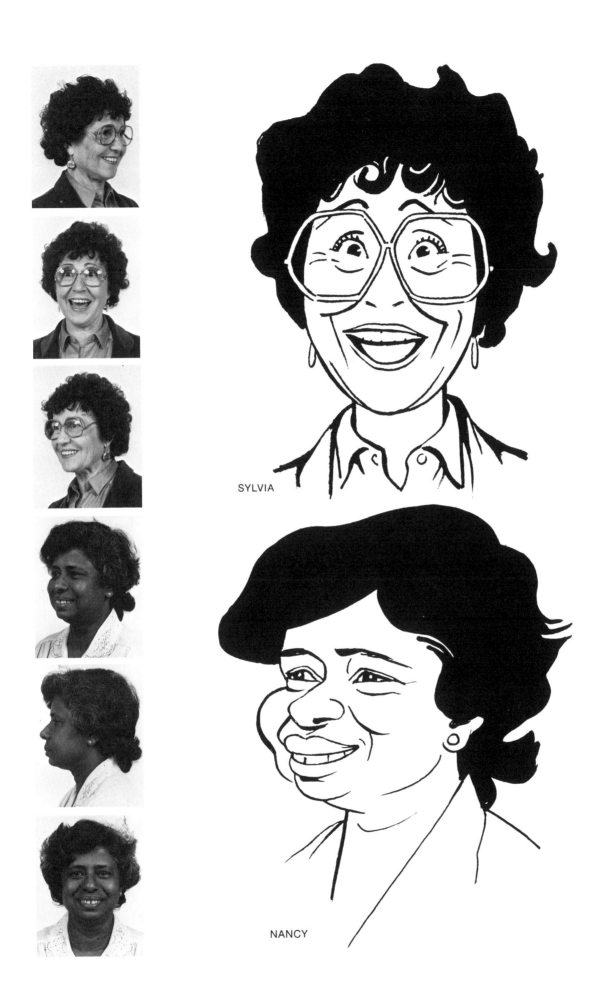

SYLVIA

NANCY

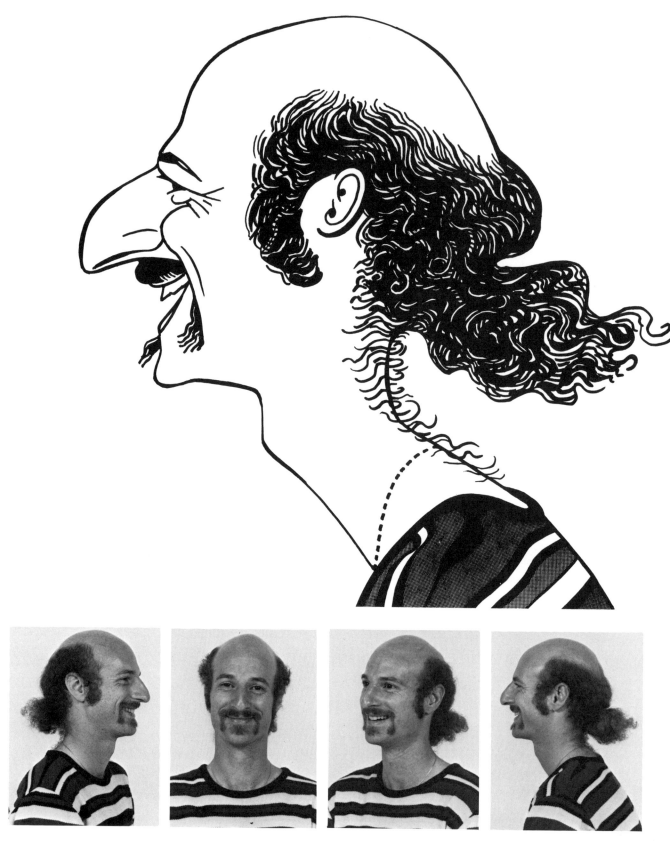

Leonard was having such a good time, I decided not to get a serious snap of him.

The photos in this book serve well for teaching but it's much better to draw caricatures from life. Why? Because a photograph has only two dimensions—height and width. The live model has, so to speak, four dimensions—height, width, depth, and personality. The model's conversation, with accompanying gestures and changing expressions, is a great help to a caricaturist, and may reveal more about a person than the features themselves. Then too, with the model at hand you can choose the view of your own liking.

A detailed explanation of the difficulties confronting a caricaturist when drawing from a photograph is given on page 95.

There is no special procedure for caricaturing from life or from a photograph. My way is not necessarily the best—but this is how I go about it:

I usually start with the eyes. The nose comes next, then the mouth, and then the outline of the head and hair—but I skip around. By skipping around I mean that if while drawing one feature I see something about another feature I hadn't noticed before, I stop drawing what I'm on and change to the other or embellish what I had already drawn. I am forced to skip around when drawing from life. The model seldom holds still and if his expression changes from the one I had already drawn to one I consider more worthy of capturing, I erase it and draw the preferred expression. If the subject begins to talk or move about, I switch to the hair until he settles down. I don't stop for a moment. Back and forth I go

from one part of the drawing to the other until it's completed. You've got to work fast when drawing from life—especially at a party.

You might have a little trouble if you choose a side view. Most of us tend to tilt our heads one way or the other, and your subjects will probably be no exception. That's comparatively easy to cope with when drawing a front or three-quarter view. But it's a nuisance when drawing the profile. When I was younger, I used to hop up and down like a jumping jack when drawing a profile in order to keep my line of vision on the same plane as the subject's head. No more! I've learned how to instruct my subjects diplomatically. Unless you're the athletic type, you should too.

I do not mean to imply it is impossible to draw a top-notch caricature of a person from the side or any other view irrespective of how the subject poses—or for that matter, if the subject poses at all. Your own aptitude will play a large part in that. And of course, there are people whose features are so pronounced that even a few scribbly lines will capture their likeness.

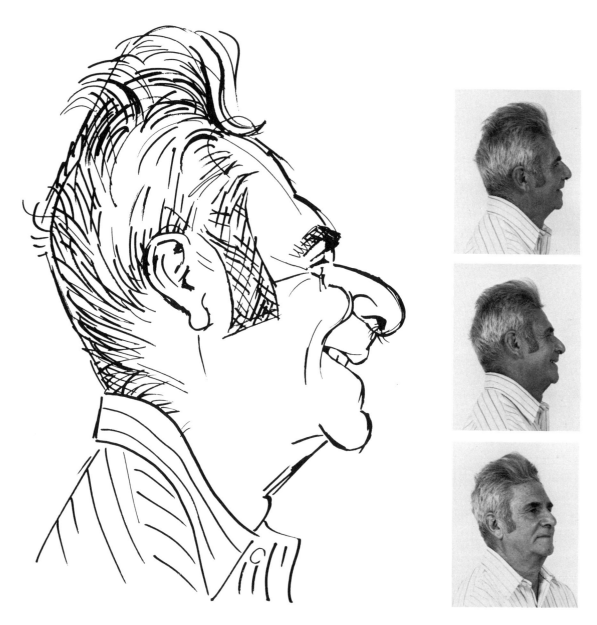

This is Norman. I asked him to tilt his head to the right and then to the left for these photographs. I did that so that you can see the problems you could have while drawing your subject if you aren't aware of his tilts. In the photograph from which I drew the caricature of him, Norman's head is tilted away from us. Consequently, his eye appears to be above the bridge of his nose, the top of his ear appears to be above his eye line, and his unique upturned nostril is conveniently visible for caricaturing.

In the photograph in which his head is tilted toward us, his eye appears to be below the bridge of his nose, the top of his ear appears to be below the eye line, and his nostril appears to be tilted downward, thus covering much of its interesting characteristics.

Most people tilt their heads so slightly that it's hardly discernable. It stands to reason that if your subject is tilting back and forth without your realizing it, you'll come up with a cockeyed drawing devoid of any resemblance.

THEY USED TO GET MAD. Watch out, some still do.

I have never deliberately offended anyone with a caricature, but it used to happen during the early part of my career. A few subjects have thrown away hats and changed hair styles; some have even wept. Abusive epithets have been hurled in my face with the torn fragments of my caricatures, and on one horrendous occasion I was choked at the neck. I confided these reactions to a client. He consoled me by saying something like this: "Your stuff is good or I wouldn't use it. In fact, it's too good for sensitive people who don't understand the art. An innocuous drawing devoid of any depth or likeness would never faze them."

Actually, my caricatures weren't so extreme in those days. The drawings of former movie stars on page 64 exemplified my style. I was in my early 20s when I drew them.

People don't get mad at me anymore. As a whole, they're more enlightened as to what a caricature is. Also, I think my subjects can tell by the way I go about it that I sincerely like them. How can you get mad at a person who likes you? Nevertheless, there

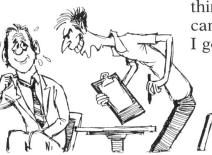
Keep your eyebrows up—not down

are frail egos floating around that are easily shattered. Such happenstance is not always avoidable but you will be more successful in not offending anyone if you smile while drawing. Just make sure your eyebrows are up while smiling—not down.

It's an entirely different story when drawing caricatures for commercial pur-

poses. Celebrities thrive on caricatures. It's a symbolic stamp of their success. Political figures are used to it and some enjoy them as much as theatrical people. President Franklin Delano Roosevelt had a hobby of collecting them of himself. During election campaigns political candidates are frequently celebrated with caricatures in the very newspapers and magazines advocating the candidate's election. All in all, it is an accepted fact: when a person has been caricatured in print, it means *he or she has arrived.*

Humor may not necessarily be incorporated in a caricature, but as you can see by the drawings in this book I usually strive for it. I try to make each caricature as funny as possible. Some of them turn out funnier than others and some more grotesque than others. This is in no way to be construed to mean I have preferential bias for those whom I draw less humorously. Please turn back to pages 14 through 17. You will notice that some of the caricatures are more loosely drawn and more extremely exaggerated than others. That's because most of them were drawn from life and the atmosphere at the parties where I drew them varied. I felt freer when the guests were gay and joyous. My drawings of them reflected our respective moods. The few that were drawn from photographs are tighter—not as extreme. The same is true of some of the caricatures on the following pages. It's because I find it much more difficult to loosen up when drawing from photographs.

Since caricatures are not flattering, I am frequently cornered into discussions about beauty. Conceptions of beauty are subjective. I skirt the subject.

64

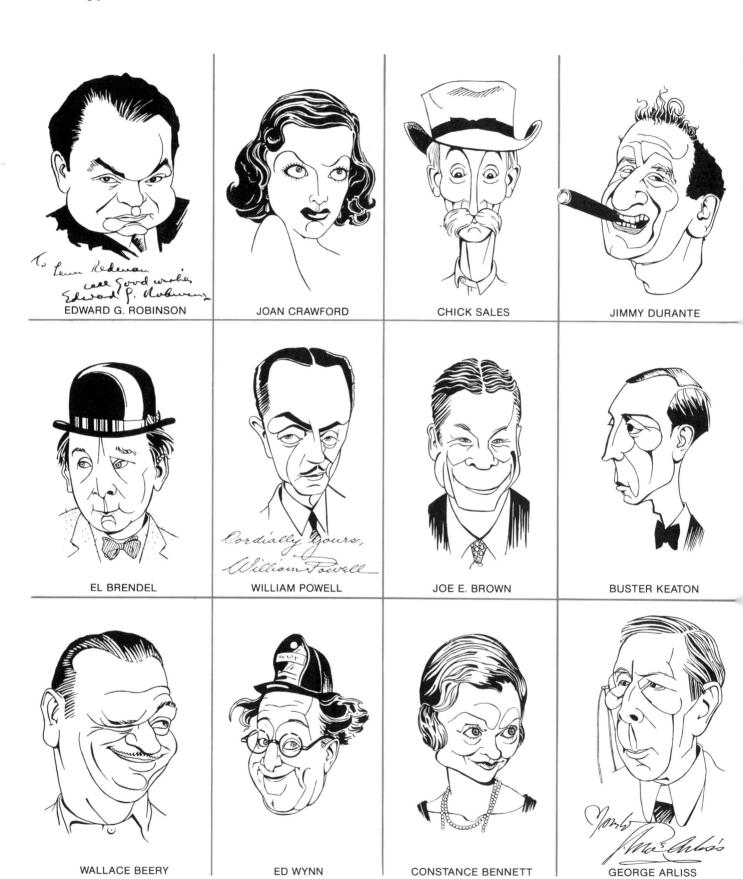

EDWARD G. ROBINSON

JOAN CRAWFORD

CHICK SALES

JIMMY DURANTE

EL BRENDEL

WILLIAM POWELL

JOE E. BROWN

BUSTER KEATON

WALLACE BEERY

ED WYNN

CONSTANCE BENNETT

GEORGE ARLISS

DO THE FEATURES OF ONE'S FACE REVEAL CHARACTER?

JOE

Life magazine once ran a two-page spread of about 40 photographs of different persons. Half of them were of college professors, scientists, and esteemed business-men. The other half were criminals ranging from thieves to rapists to murderers. The magazine feature was a fun contest for the reader to see if he could tell the good citizens from the criminals. My wife and I tried it. My score was about 30 percent right; her score was 100 percent right. Did she have special insight? Yes, but not about faces. She observed that half the photographs had the same draped background and deduced correctly that the criminals were photographed at the same locale.

Albert Einstein is one of my favorite heroes. Did he look like what he was? Take a peek at him on page 17. He's number 65.

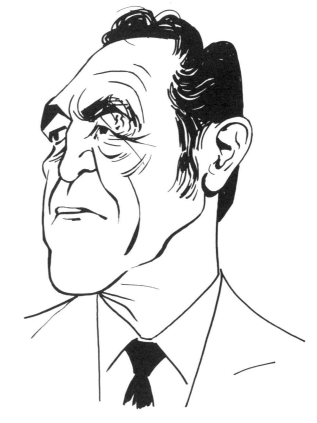

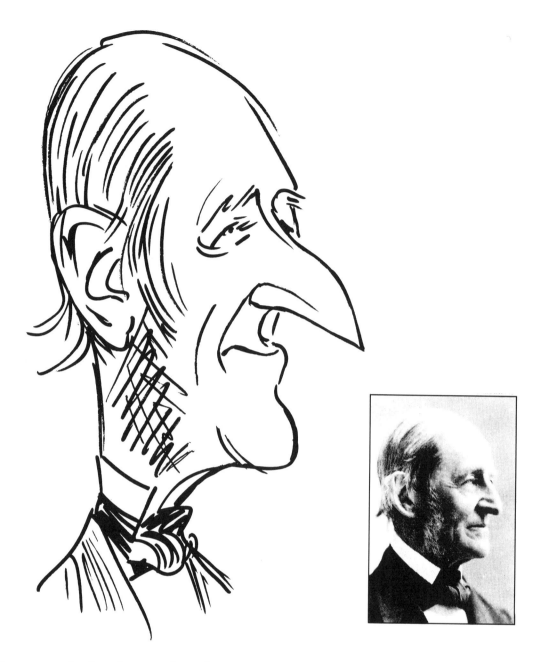

Physiognomy is the theory that the size and shape of a person's features disclose personality and character traits. If the nose turns up it means one thing, and if it turns down it means something else; if the forehead is high, it means this, and if it is low, it means that; if the chin protrudes, *hurray*, if it recedes, *oyvey*.

The theory of physiognomy was discredited a long time ago but we still suffer its influence. Storybook and play writers promulgate the nonsense in their character descriptions. Here's one I clipped out of a newspaper about 25 years ago describing Indira Gandhi: ". . . she is a slim, handsome woman with the aristocratic features of the Gandhi family." Descriptions like that frustrate me. What do aristocratic features look like anyway? Here's one I read recently: "He had a sharp clever nose . . ." Do you know what a *clever* nose looks like? I certainly don't. I like my own description of a sharp nose better: "It could burst a balloon."

From childhood on we're conditioned into prejudices about certain types of faces by the way children's books portray their characters. In my adolescent days, evil witches were always illustrated with large, hooked, bumpy noses. And to give them extra impact, some of the witches were given moles on the tips of their noses with hairs growing out of them. The fact is, I've known a few witches in my day and they all had pretty noses.

Adolph Hitler was a diabolical monster, but his face was so nondescript and so unlike Hollywood's portrayal of a bad person that a casual meeting with him wouldn't faze you if you didn't know who he was or what he stood for.

Conversely, the man on page 65 looks like someone you'd be afraid to meet in a dark alley in the middle of the night. He's

esthetic look usually attributed to fine artists. If you saw him on the street, not knowing who he was, and were asked what you thought was his occupation, you'd probably come up with something like plumber, barber, or accountant.

Now turn back to page 26. Would you ever suspect that a face like that belongs to an intelligent lawyer with a terrific sense of humor? It does.

You hear people parrot the cliche, "The eyes are the mirrors of the soul." What they are saying, in effect, is that by looking at the eyes, you can tell what's behind them. I don't buy that at all. As far as I'm concerned, the eyeballs are wonderful organs to see with and can reveal one's state of health or sickness. That's plenty. Why ask for more? The lines around the mouth and elsewhere on the face, and the eyebrows that

my good friend Joe—a kind, considerate, thoughtful, gentle man.

The fellow on page 66 has a head so narrow, one might think his brain cells are defective. Who is he? None other than one of history's most lustrous minds, Ralph Waldo Emerson.

Pablo Picasso is on page 128. He certainly didn't have the slender, sensitive

change their shape and bob up and down with emotional vigor, signify people's momentary attitudes—that is all. But even for that, they are not always dependable signals. The fellow on page 27 is at peace with himself. He did not deliberately assume an angry expression for the photograph. It's the way he always looks when he's not smiling.

Bodies Can Be Caricatured, Too

It's fun to draw faces but professional caricaturists have to have a more rounded understanding of art.

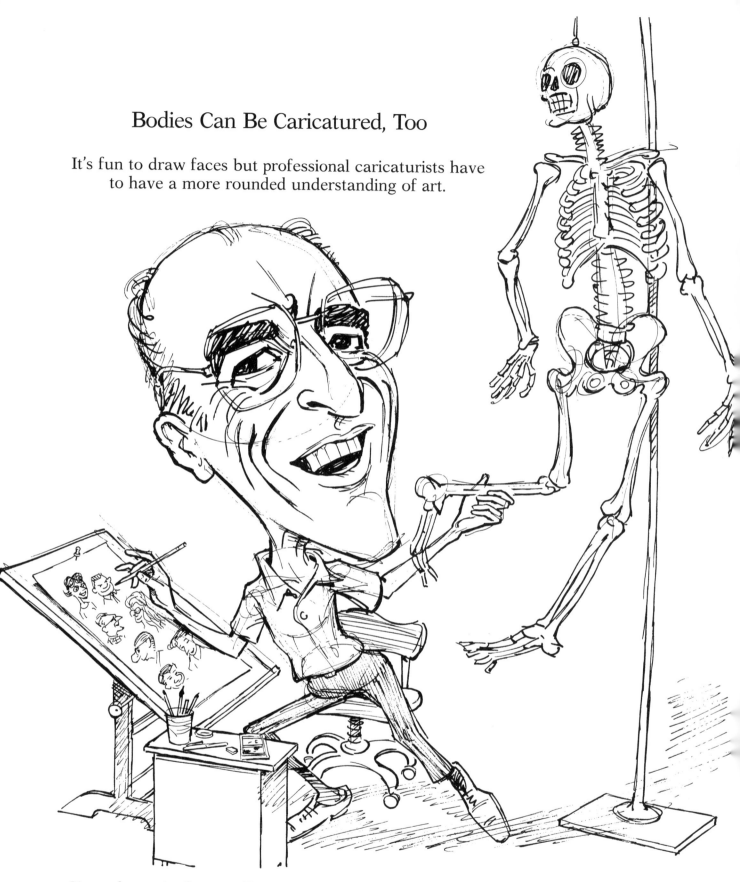

Since the entire human figure is caricaturable, I must particularly impress upon you the importance of learning as much as possible about the human anatomy. You needn't keep a skeleton at home for the purpose but it wouldn't hurt to study a book or two on the subject and/or go to a life class. The few pages devoted here to the subject barely scratch the surface.

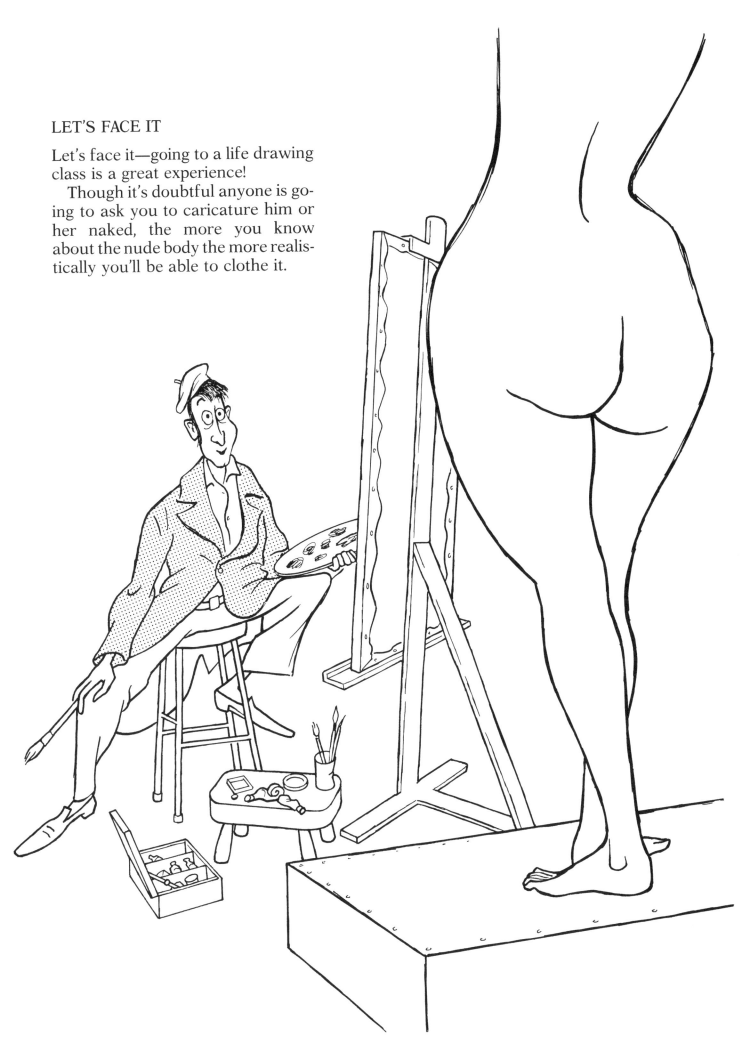

LET'S FACE IT

Let's face it—going to a life drawing class is a great experience!

Though it's doubtful anyone is going to ask you to caricature him or her naked, the more you know about the nude body the more realistically you'll be able to clothe it.

THE IN-BETWEENER'S BODY

The In-betweener is bigeneric. He looks more like a man, but for caricaturing purposes, he is neuter. I have not gone wrong—nor will you—by using him as a standard for comparison while caricaturing women.

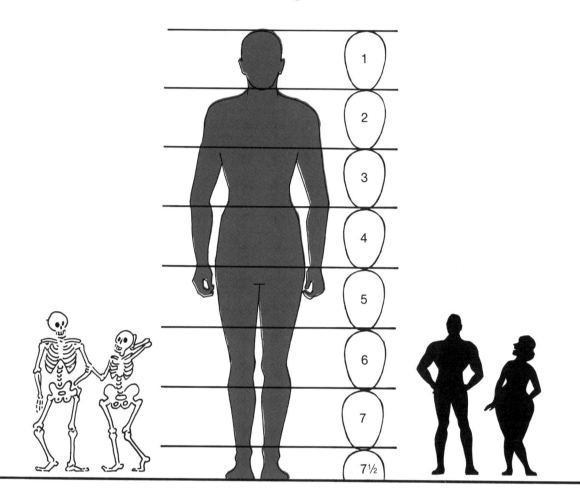

The In-betweener, whether configured as a man or a woman, is 7½ heads tall. The average woman is smaller, softer, rounder, and more curvilinear than the male. Her chest is smaller and her pelvis proportionally larger. She has more flesh on her chest, hips, and buttocks. Her posture, motions, and gait are also enjoyably different from that of the male. All of these niceties are caricaturable. If your subject's height is more than 7½ heads tall, your drawing of him or her could be proportioned out of 8 or 9 or more head measurements. If he or she is less than 7½ heads tall, you could reverse the exaggeration. Usually (but not necessarily) tall people have small heads and short people have large heads compared to the rest of their bodies.

When caricaturing the entire body, relativity's two parts are as applicable as when drawing the face. With the aid of the In-betweener as a frame of reference, you can exaggerate whatever is different about your subject's body from other people's.

NECK AND SHOULDERS

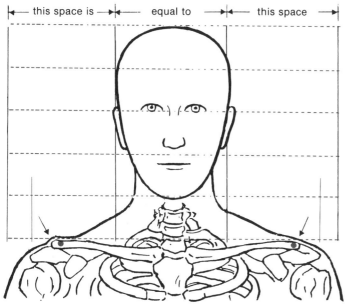

this space is → ← equal to → ← this space →

The width of the In-betweener's shoulders is a little less than three times the width of his head.

When the In-betweener's head is erect, the distance between the bottom of his chin and the top of his collarbone is equal to one-fourth the distance between the top of his head and the bottom of his chin. That determines the length of his neck.

The In-betweener's neck and shoulder dimensions are not the same as yours and mine.

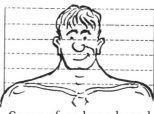

Some of us have broad shoulders.

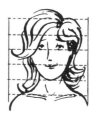

Some of us have narrow shoulders.

Some of us have short necks.

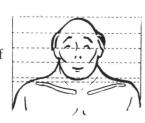

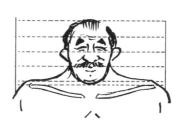

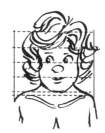

Notice how high the collarbones are on these three.

Some of us have long necks.

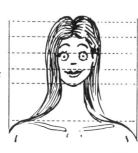

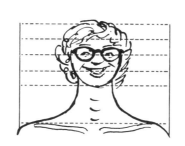

Notice how low the collarbones are on these three.

ARMS

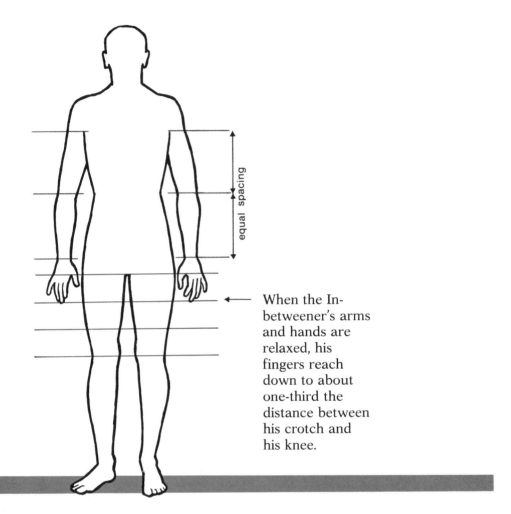

equal spacing

When the In-betweener's arms and hands are relaxed, his fingers reach down to about one-third the distance between his crotch and his knee.

An easy way to decide your subject's arm proportions is by using his armpit and wrist as a measuring gauge. The In-betweener's elbow is halfway between them. However, your subject's elbow may not be halfway between—

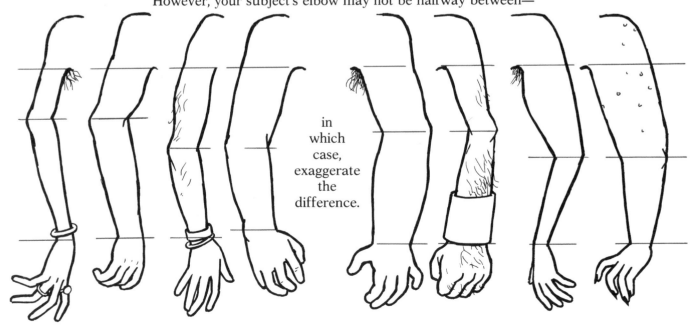

in which case, exaggerate the difference.

LEGS

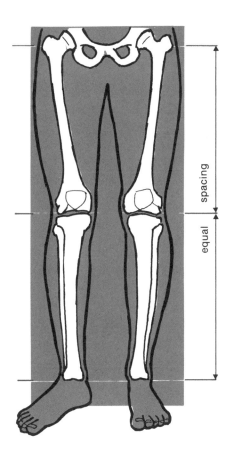

The In-betweener's knees are halfway between his pelvis and his ankles. That's not the way it is with everyone. Some knees are lower and some are higher.

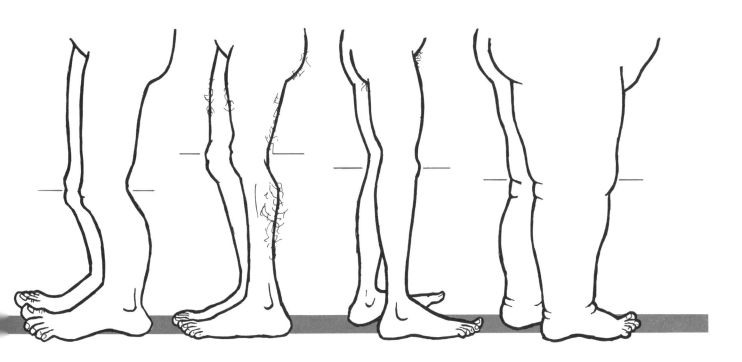

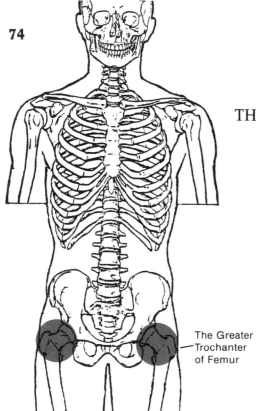

THE IN-BETWEENER'S MIDDLE

The anatomy books have fancy names for all parts of the body. Here's a classic: The Greater Trochanter of Femur. It is the protrusion of the upper part of the thighbone. I call your attention to it because it makes a convenient identifying location for the pivoting joint attached to the pelvis. It is exactly halfway between the top of the In-betweener's head and the bottom of his feet.

The Greater Trochanter of Femur

Notice its location relative to the In-betweener's buttocks. It's in the center.

It's lower on some people—

and higher on others.

Therefore, exaggerate the difference.

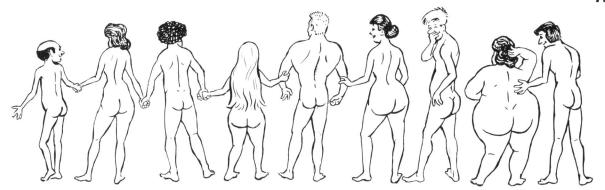

The bones and muscles

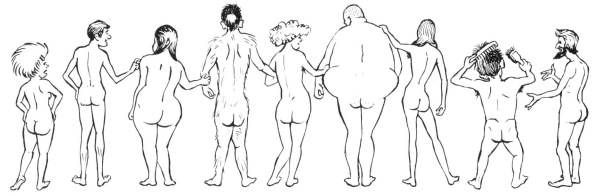

of this motley group

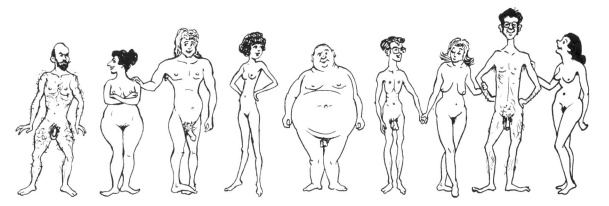

have fancy names, too.

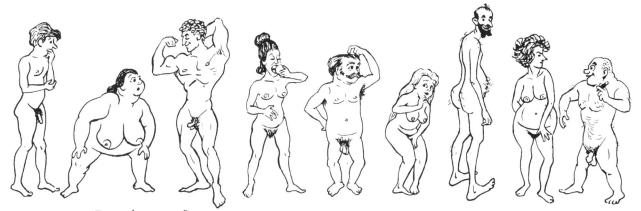

But who cares?

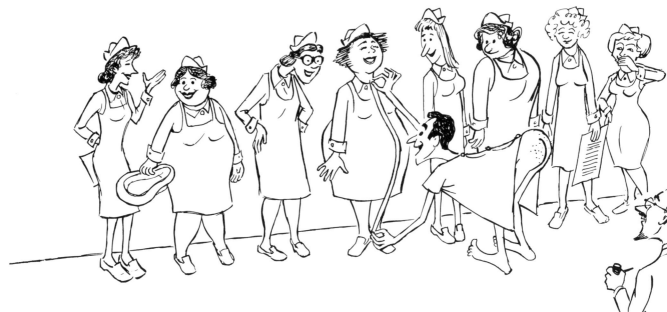

That's right. Who cares? I've been emphasizing the importance of understanding anatomy. I don't mean you should necessarily attempt to know all the details about every bone and muscle. I have no such thorough knowledge (very few artists do). What I mean is that you should understand it enough to be able to envisage the In-betweener. That way when you are drawing a person full-length, you will be able to relate the sizes of (and spaces between) the external parts of your subject's body with each other and exaggerate them accordingly.

Several years ago when I first conceived the idea of an In-betweener for caricaturing, I was presented with sufficient time and convenience to test my theory. I was confined in a hospital for a few days. My sickness wasn't serious enough to immobilize me so I got a few nurses to line up against the wall and I measured them. It created great interest. Interns and doctors who didn't belong to our ward came in to watch. So did the barber, beautician, and visitors of other patients. But I didn't care—in fact, I enjoyed it. So did everyone else. I found out where each nurse's head, shoulders, belly button, hips, knees, and a few other things were in relation to each other.

As for proving the truth of my In-betweener theory, my findings were far from conclusive—but it sure was fun.

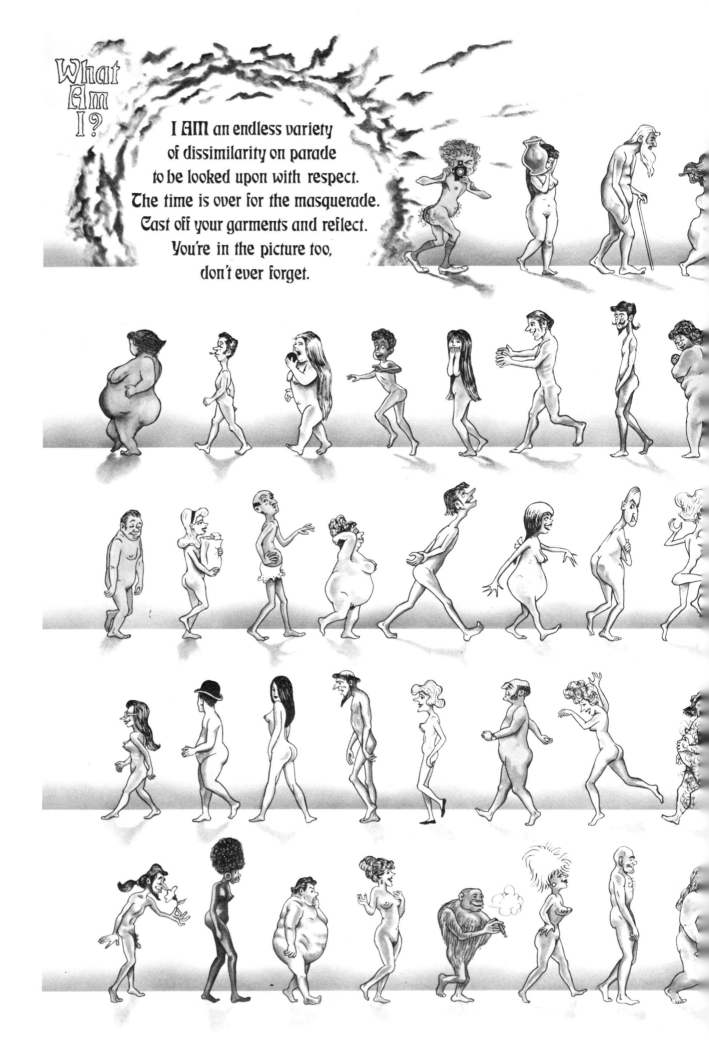

What Am I?

I AM an endless variety
of dissimilarity on parade
to be looked upon with respect.
The time is over for the masquerade.
Cast off your garments and reflect.
You're in the picture too,
don't ever forget.

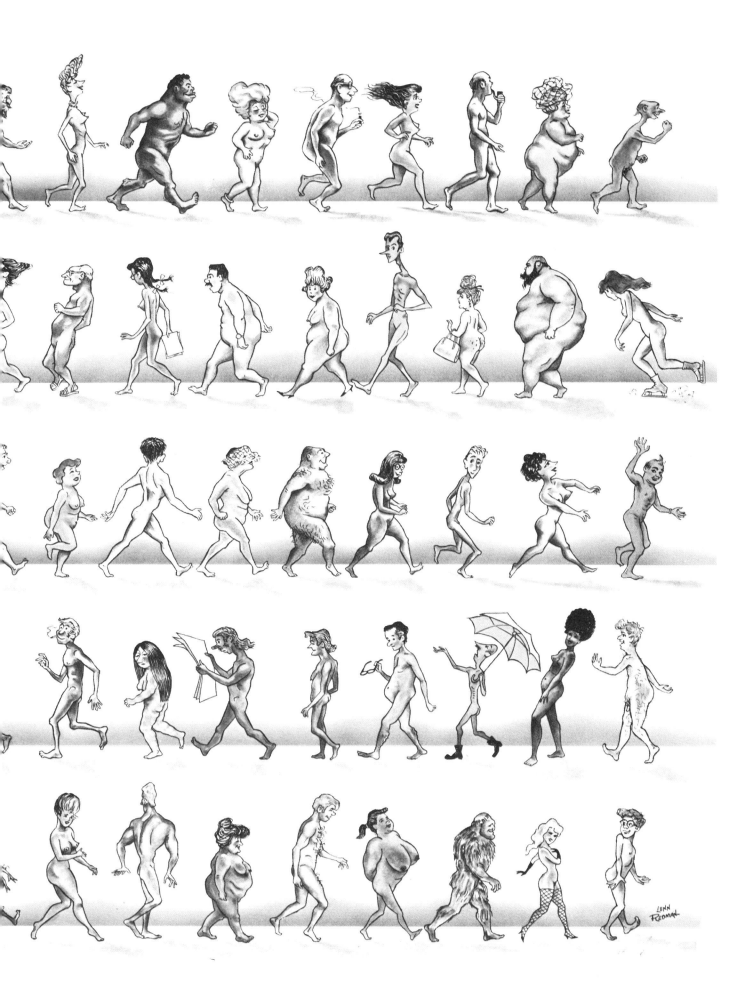

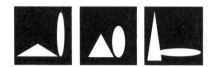

My explanation about caricaturing a face (page 32) pertaining to Relativity Part 2 also applies to caricaturing the entire body. By exaggerating one part of the body, the other parts might assume an appearance other than their true construction. Consequently their appearance may be exaggerated, as well as (and in some cases instead of) their true construction.

For example, though an obese person's legs might be shaped very much like the In-betweener's legs, you could justifiably make them thinner in order to emphasize the fatness of his or her torso. Or if the converse were true, you could do the exact opposite.

This theory is applicable to all kinds of drawing. A fat person can be portrayed fatter by setting narrow objects or thin people in the same illustration, and a child can be made to appear smaller by setting him in the midst of grown-ups or large objects. Exaggerating the dissimilarity of people in the same scene is an offshoot of this facet of caricaturing. It's a humorous method of emphasizing each individual's uniqueness.

Besides being human, the only thing similar about the above assemblage is their conviviality and their apparent economic and social status. The people parading on pages 78 and 79 have been stripped of social status. Nudity tends to do that—don't you think?

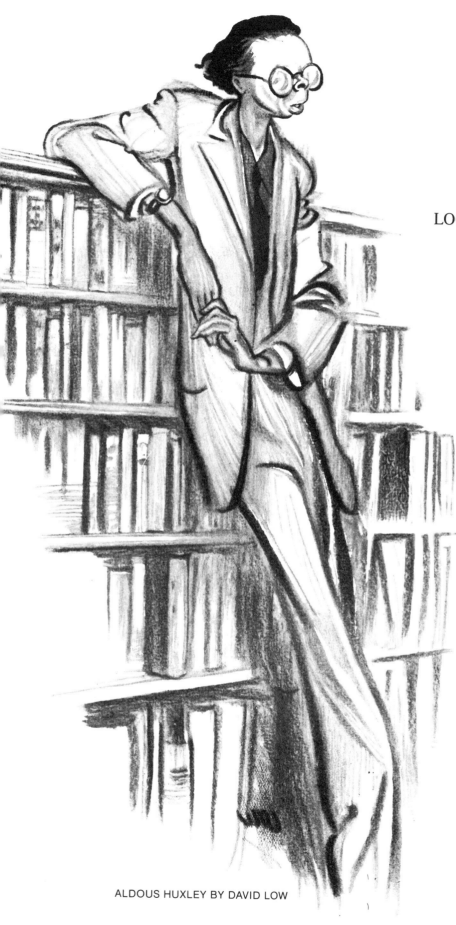

ALDOUS HUXLEY BY DAVID LOW

LOOK FOR THE SUBTLETIES

Let's talk about how we look as we are ordinarily seen—with clothes on, that is. Bear in mind the obvious may not be what truly distinguishes your subject from everyone else. Look for the subtleties. Lots of people have big noses, big feet, big mouths, big stomachs, big ears, big rumps, etc., and lots of people have the reverse of all these things. An accomplished caricaturist is equally interested in that certain twist of the lips, angle of the hips, tilt of the head, faraway look, enigmatic smile, and every other characteristic quality that individually or collectively makes your subject totally different from everyone else.

A person with a double chin who tries to camouflage it with head lifted high, a person with a peculiarity of the teeth who, when wanting to smile, tries to conceal it with a squinched face and pursed mouth, a person who habitually has a hand or finger somewhere on his face all lend themselves well to caricature.

David Low, a deservedly famous English caricaturist of the early and middle 1900s, excelled at caricaturing every facet of his subject in a most realistic way.

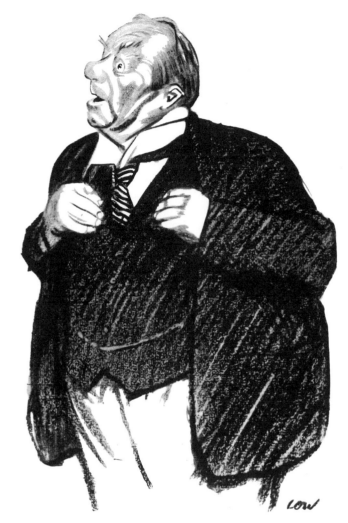

MR. BALDWIN

These drawings and the one on the preceding page were reproduced from *Ringmaster*, published in 1936. The drawings originally appeared in *Ye Madde Designer*, published in London by the Studio Limited.

Mr. Low was a master at capturing his subjects' posture, stance, gait, and gestures.

HILAIRE BELLOC

CLOTHING

Styles change from one decade to the other but certain principles about a person's clothing remain true at all times.

Consider this while drawing a person full length: Clothing does not hang like a board. It drapes with creases, wrinkles, and folds. How it hangs is determined by body movements and by how tightly or loosely it fits. The larger and looser the garment, the larger and looser its creases, wrinkles, and folds; the smaller and tighter the garment, the smaller and tighter its creases, wrinkles, and folds.

Elbows and knees cause wrinkles when bent. Wrinkles begin at the bends and aim at the protruding joints. Any tight-fitting garment will wrinkle toward any protruding object within the garment. Also, wrinkles tend to form at the seams when the garment is stretched.

You may eventually choose not to draw wrinkles in your clothed figures. Some caricatures look better without wrinkles—but you should definitely learn how to draw them.

Turn the page and see how I clothed some of the figures on page 78 and page 79.

It might be good practice for you to copy a few of the other nudes on parade and see what kind of job you can do clothing them.

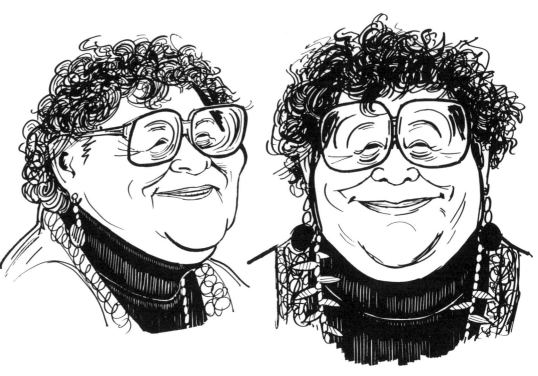

I knocked myself out for several hours on these two drawings.
Then I said, "What the hell!"
and I drew
this in less
than two
minutes.

KAY

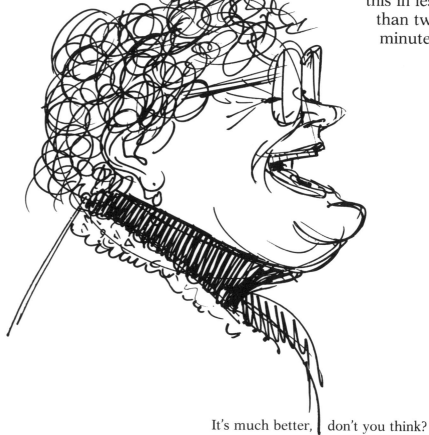

It's much better, don't you think?

THE VALUE OF SKETCHING

Now that you've learned something about the human anatomy and how to clothe it, it's time you begin practicing by sketching. I recommend you carry a sketchbook around with you wherever you go and fill it up. That's what I used to do. I carried one with me for years and drew whenever I was inspired—which was often. I learned a lot that way. And it made a terrific diary, for I annotated each page with date, location, and other pertinent information.

The value of sketching is that the more you do it, the more likely you'll improve. It will also give you confidence and loosen you up. Loosening up means drawing quickly with your whole arm rather than just your fingers—finger drawing tends to "tighten" you up.

The following drawings are excerpted from one of my sketchbooks. They were drawn directly with a thin felt marking pen and without preliminary pencil sketching. The lines dried as they were applied, thus enabling me to draw quickly without concerning myself about smudging. When I scribbled a line I didn't like, I was compelled to leave it and continue on. It was just as well, for a quick spontaneous sketch has a charm frequently lost on the more belabored ones. Some of my less complicated sketches took me no more than three or four minutes. None of the subjects posed and most of them didn't know I was drawing them.

Excluding the sketch on page 93 which is reproduced almost the same size as the original, these drawings were just about half again larger.

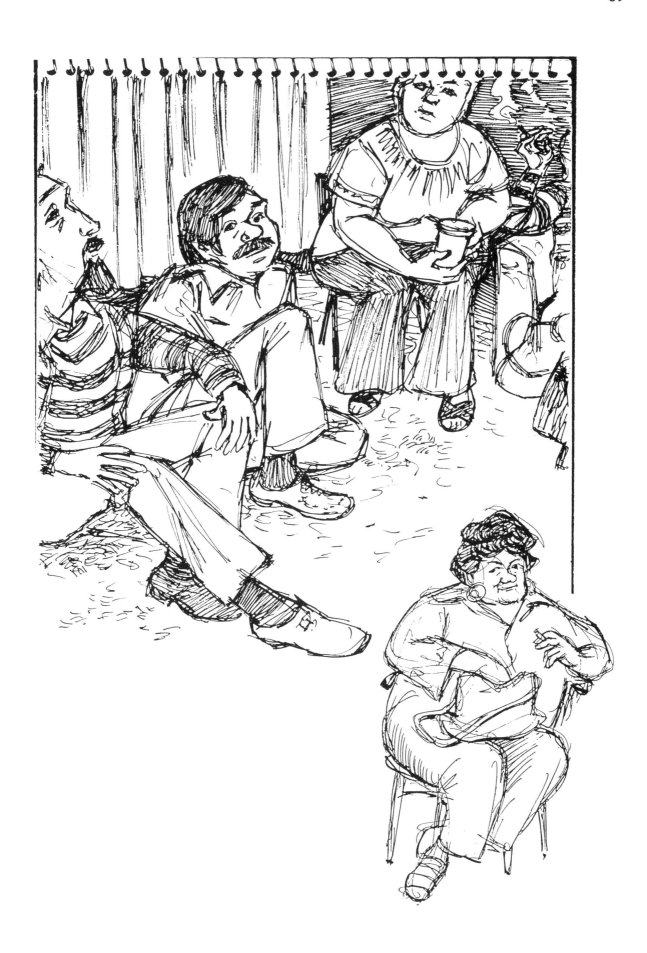

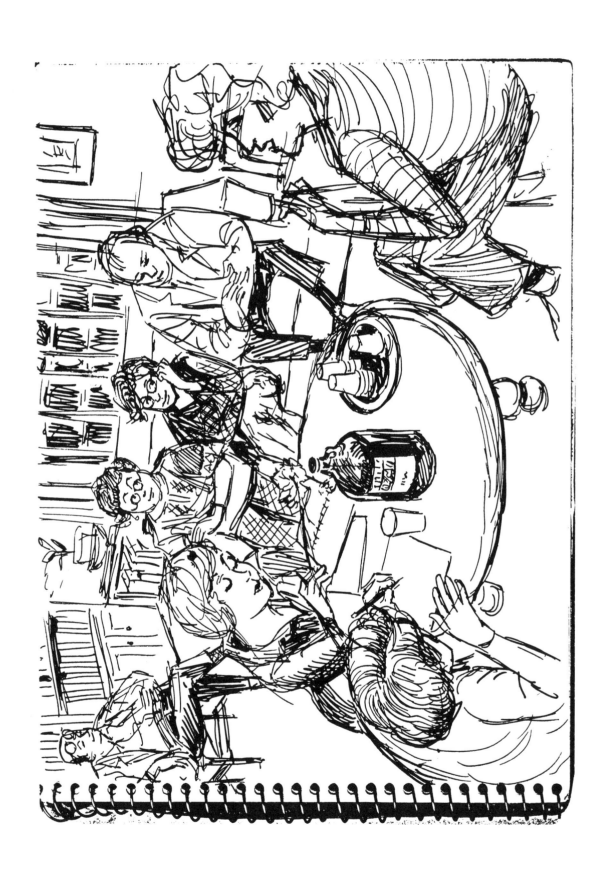

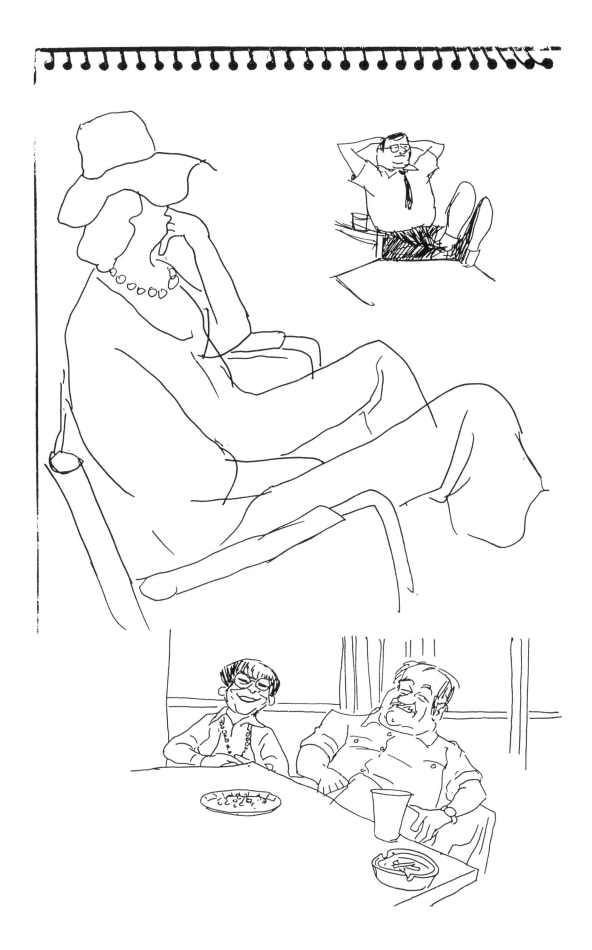

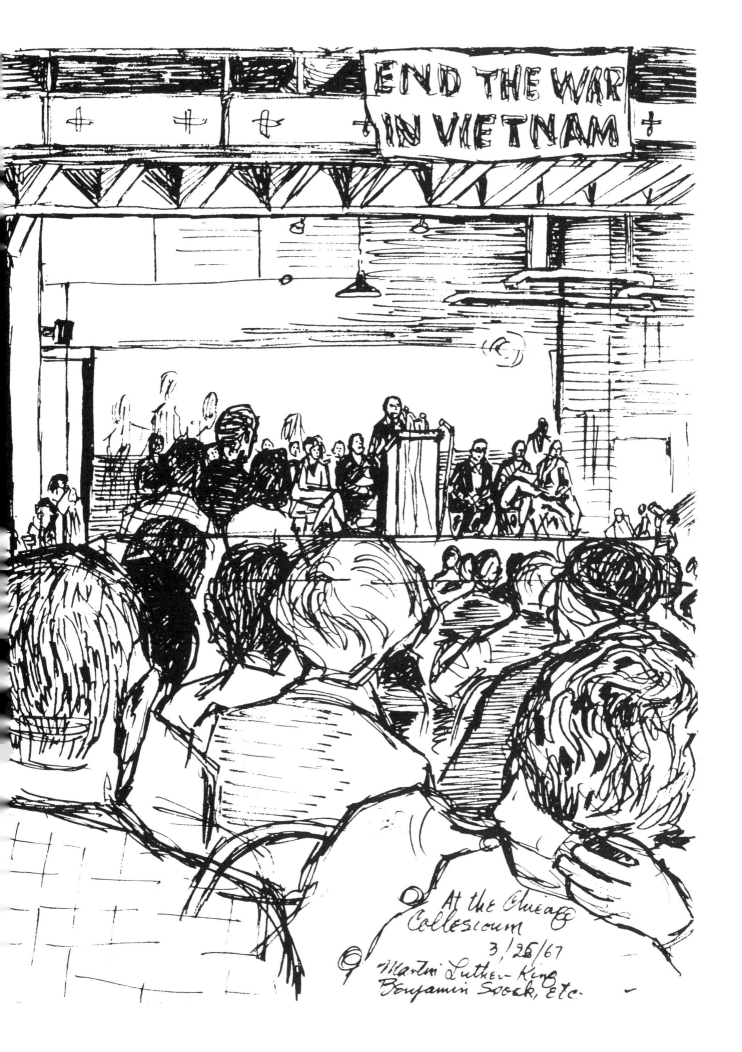

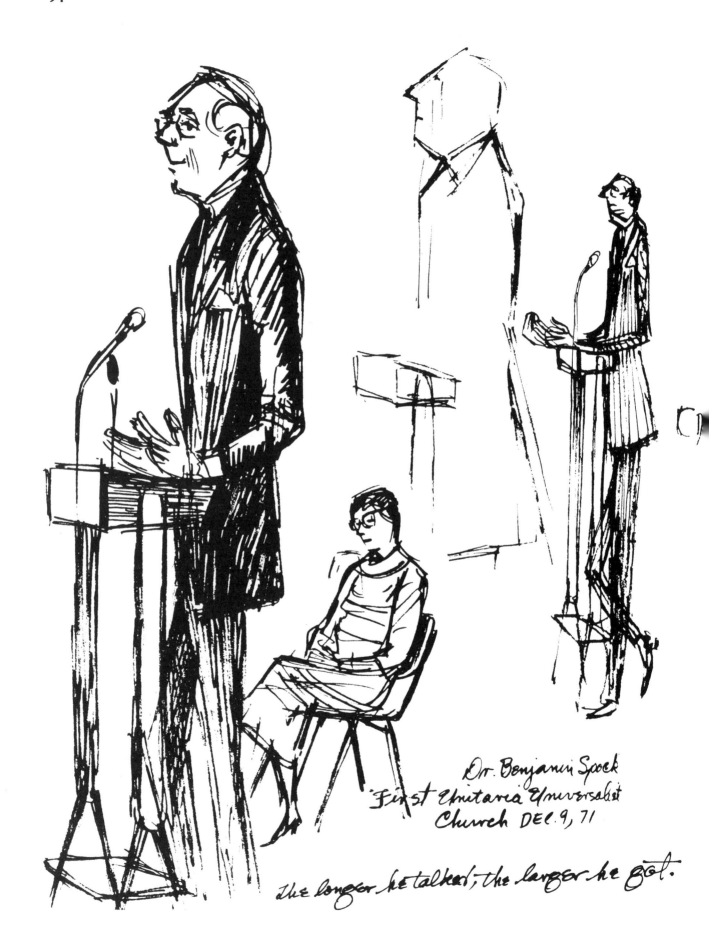

Dr. Benjamin Spock
First Unitarian Universalist
Church DEC. 9, 71

The longer he talked, the larger he got.

DRAWING FROM PHOTOGRAPHS

This photo is of Archie. It was easy to work from.

People seldom behave naturally when they pose for a studio photograph, and it gripes me when I'm restricted to one from which to draw. They're usually front views. Unless you've seen your subject before and have memorized his face, a front view photo, with the subject posed to look as "good" as possible, has little value. With such a photo, how do you determine to what extent the subject's forehead, nose, lips, cheekbones, and chin protrude or recede? To make matters worse, with special lighting and shadow casting photographers tend to camouflage double chins, Adam's apples, laugh wrinkles, and other important character lines. And as if that weren't enough, they shoot their negatives out to some photo-retoucher who emasculates them completely. Result? Vapid-looking store-window mannequins.

If you must draw from photographs, the candid ones are the best. They are the most natural and are rarely retouched. (Most of the photographs in this book aren't candid, but I took them and therefore controlled all the poses.) So use photographs to practice, but when you choose photographs from newspapers and magazines to draw from, make it easy on yourself—choose the ones that are candid.

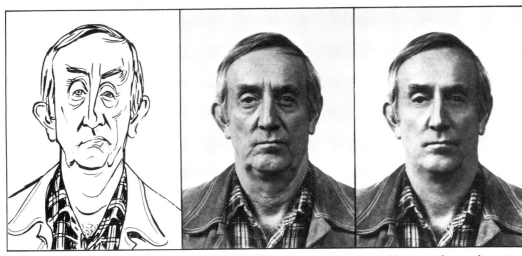

I drew this caricature . . . from this photo. I could never have done it
 from this highly retouched one.

John is very difficult to caricature from the front. I would have had a rough time of it if a front view photograph of him was the only one available.

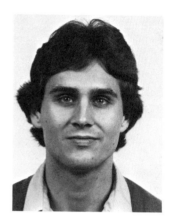

JOHN

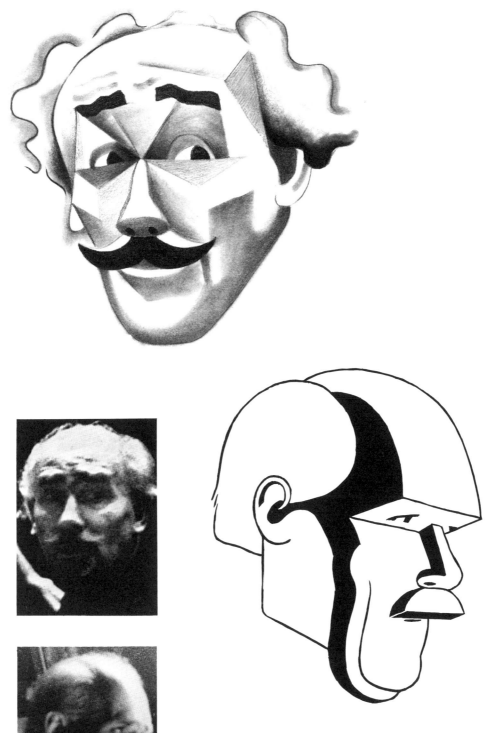

Both of these photographs are from newspaper clippings. They're of Arturo Toscanini. The first one is so poor, you can't tell how big or small his chin is. The other one is somewhat better but they don't look like they belong to the same person. Incidentally, this type of drawing is described in the chapters on three-dimensional drawing and abstract impressionism.

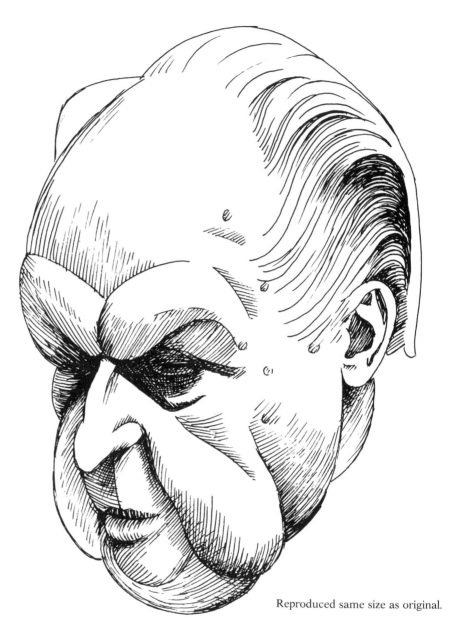

Reproduced same size as original.

This photograph of Leopold Stokowski, also from a newspaper clipping, is better—but I would have preferred a photo with clearer delineation of his eyes and lips.

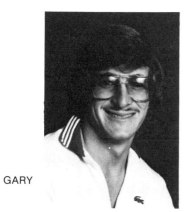

GARY

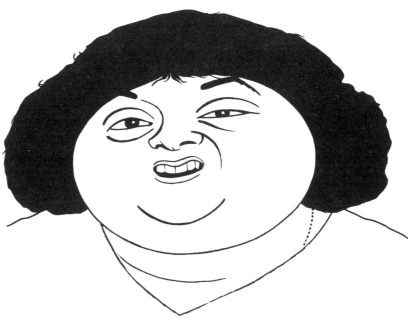

These two young men handed me their photographs to draw from. I was happy, in fact eager, to accept them. They are both excellent subjects. The photos didn't come out as they would have had I taken them. I try to avoid photos with shadows because, as you can see by the ones of Arturo Toscanini and Leopold Stokowski, they tend to camouflage important features. In Gary's photo the shadows did the exact opposite: they emphasized his dominant features.

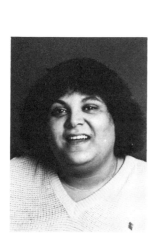

BOBBY

CHILDREN

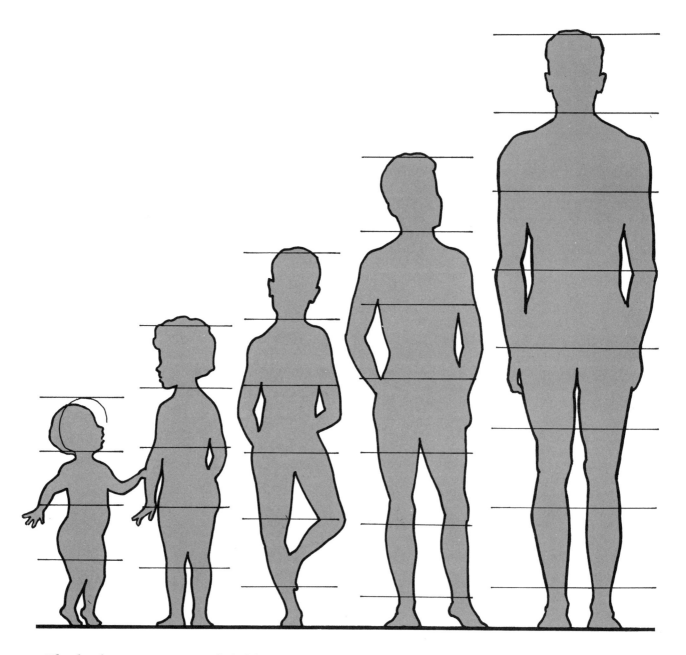

The body proportions of children change so fast and at such varying rates of speed, it would be impossible to formulate an in-between type for them during any stage of their growth.

When drawing children, what's important to know is that an infant's legs are short, the body is long, and the head is large porportionate to the legs and body. As the child matures, the body and legs grow faster than the head.

Body proportions are not all that need to be considered when caricaturing a child full length. A child's cute and loving behavior is enjoyably caricaturable.

The drawings on the next page were sketched from snapshots of my son as he grew up.

JAMES

MELISSA

If you are able to capture your subject's likeness with just a few lines and you choose to do so, fine. If you prefer to go into more detail, that's okay, too.

I love kids. This one used to live across the street from me. Mischevious? He got into everything.

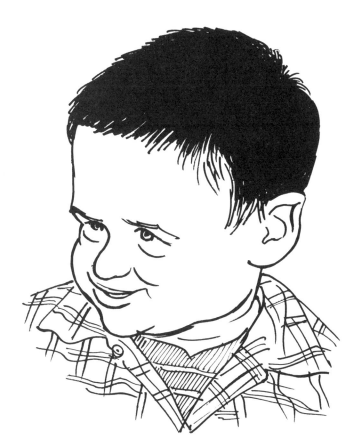

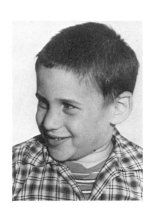

ADAM

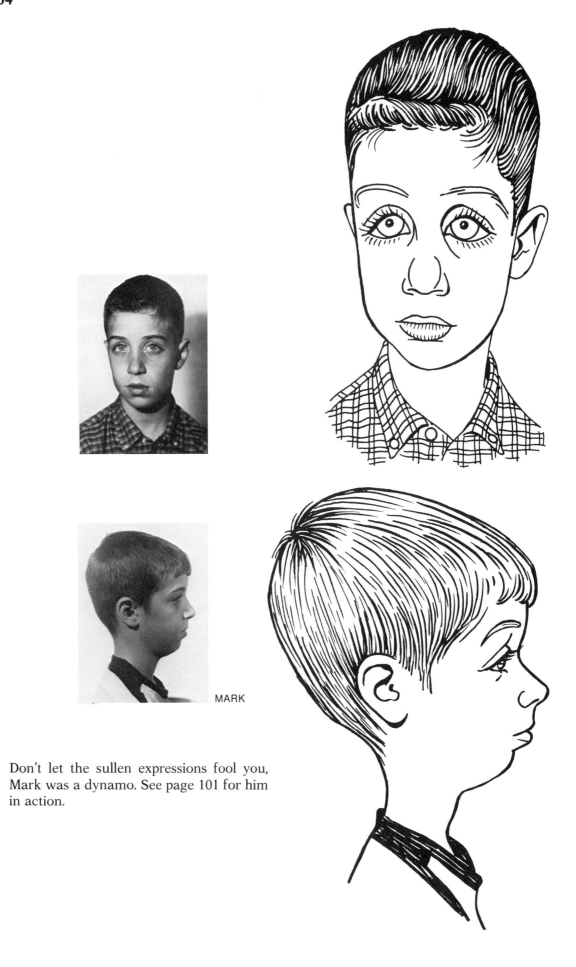

MARK

Don't let the sullen expressions fool you, Mark was a dynamo. See page 101 for him in action.

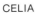
CELIA

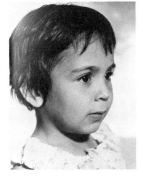

"Eyes as large as saucers," was a phrase used for Celia when this was drawn.

On pages 126 and 127 I show how the features of one's face may be drawn in such a way as to incorporate the artist's attitude about the subject or something for which the subject is known.

I almost succumbed to the temptation of drawing Celia's beautiful large eyes as saucers but I decided it would detract from her cuteness.

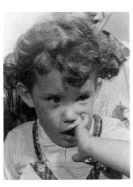

SUSAN

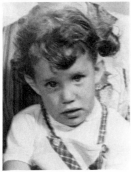

I chose the upper photograph of Suzy to work from because it caught her with her finger in her mouth. The action is more typical of a child and, I think, cuter.

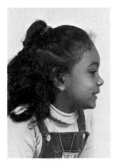
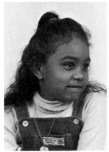
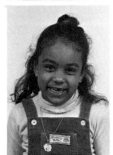

JENNIFER

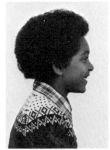

D'MITRI

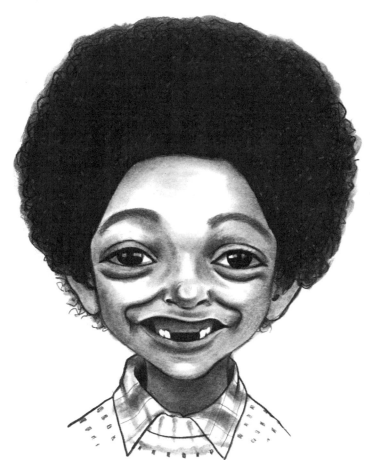

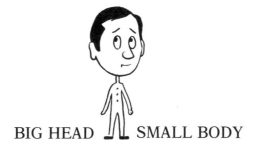

BIG HEAD SMALL BODY

The caricaturist assigned to draw someone full length is usually expected to emphasize the subject's likeness by drawing the head much larger than the body. This means important physical characteristics must be omitted—the thickness and length of the neck, the width of the shoulders, and the way the subject's head might tilt can't easily be shown. However, if the situation illustrated contains sufficient humor and/or interest, it more than compensates for these omissions.

The graphic distortion of a large head on a small body is difficult to make look anatomically plausible. The difficulty is in drawing a top-heavy head so that it doesn't look like it's about to fall off a puny neck. I've seen too many caricatures like that. The way to avoid that mistake is by drawing the shoulders broader and the neck shorter and wider. Another way is by not drawing the neck at all. The head will appear to have more support when resting directly on the shoulders. Then too, other objects in the illustration can be drawn to counterbalance the visual weight of the enlarged head.

By counterbalancing visual weight, I mean this: The elements in an illustration that attract more attention than its other elements may be regarded as having more "weight." Excluding the tremendous effect *color* has on weight in an illustration, large objects and black objects usually carry the most weight. The location of the objects in your illustration also has a bearing on their respective weights. It is important that you keep all the elements of your illustration in balance.

The cartoon above is worth examining. The poor guy's head is much too heavy for him—ordinarily I would have given him a wider neck or no neck at all. I drew him as I did to illustrate a point: Even with the amateurishness of so thin a neck, the drawing is saved by my having placed him in the middle of the caption. The large print, "BIG HEAD SMALL BODY" at the base of his legs has a stabilizing effect; it counterbalances the top-heaviness of his head.

All elements in the following drawings are balanced correctly.

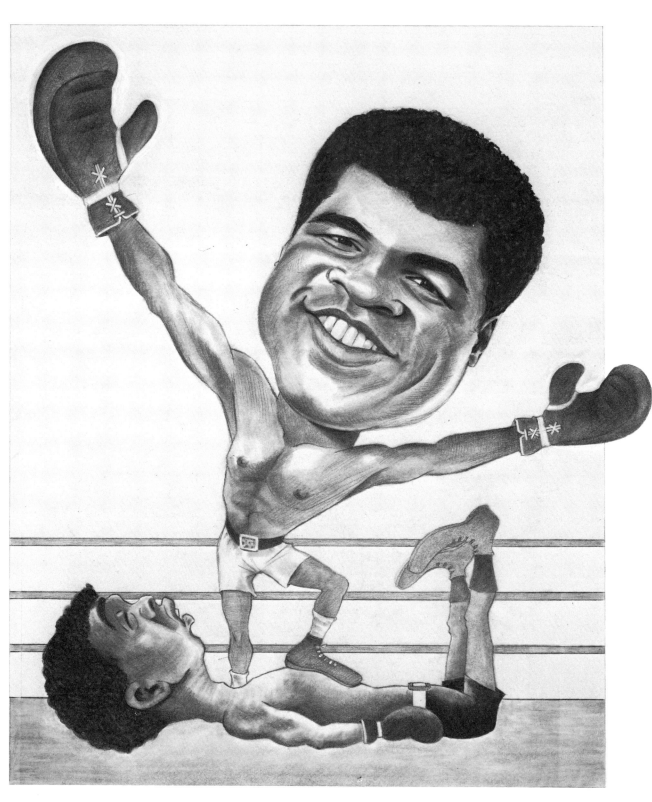

MUHAMMAD ALI

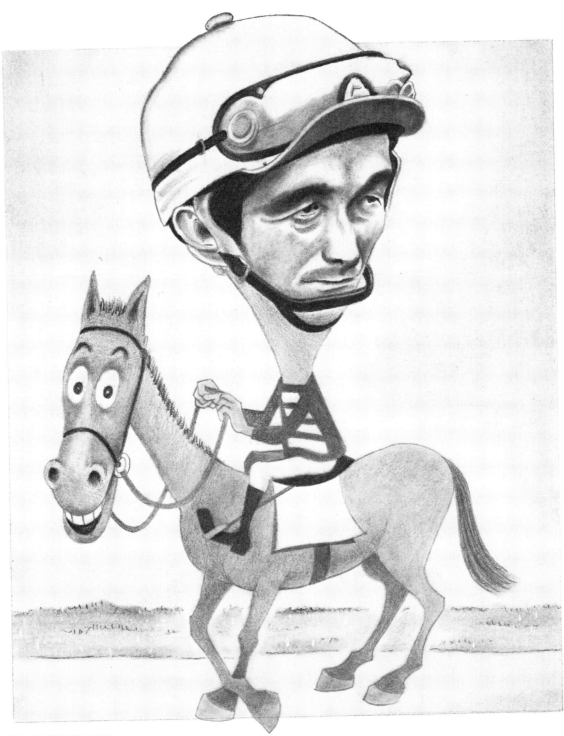

WILLIE SHOEMAKER

These big-headed fellows are of no one in particular. They are examples of the type of caricature I frequently draw for an organization as part of a program to honor a special person. I'm sorry I don't have some originals to show you. The situations drawn are always based on information given me about the subjects—their hobbies, occupations, idiosyncrasies, lifestyle. I use different media at different times: Charcoal, ink, pastel, watercolor, and oil are used, depending upon the sponsor's requirements or my mood at the time of the assignment. The caricature is framed and given to the individual at the party honoring him, and is always appreciated.

You might consider soliciting assignments of this type. Birthdays, anniversaries, weddings, and retirement parties are suitable occasions for such gifts.

These caricatures and the ones on the next six pages are shown through the courtesy of Mr. and Mrs. Joseph Bossi of Chatsworth, California. The originals hanging on their living room walls are in full color and vary in size. None of them are less than 18″ × 24″. The ones on this page are of their children.

The caricatures following are of old-time comedians and humorists. I have included them in the book because of their historical significance and as examples of more drawings of large heads on small bodies.

KELLY

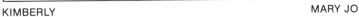

KIMBERLY

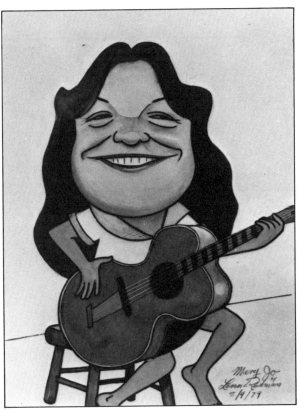

MARY JO

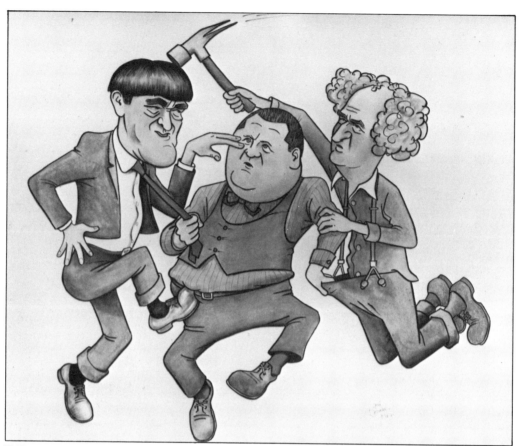

THE THREE STOOGES—CURLY, MOE, and LARRY

GEORGE BURNS and GRACIE ALLEN

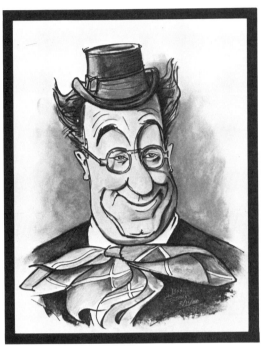

ED WYNN

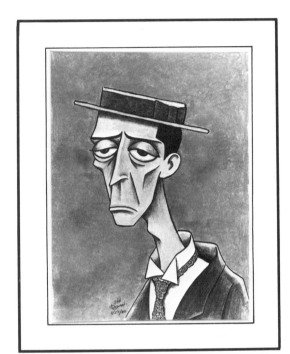

BUSTER KEATON

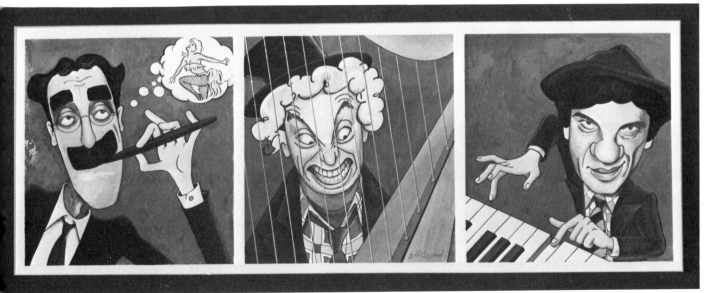

GROUCHO HARPO CHICO

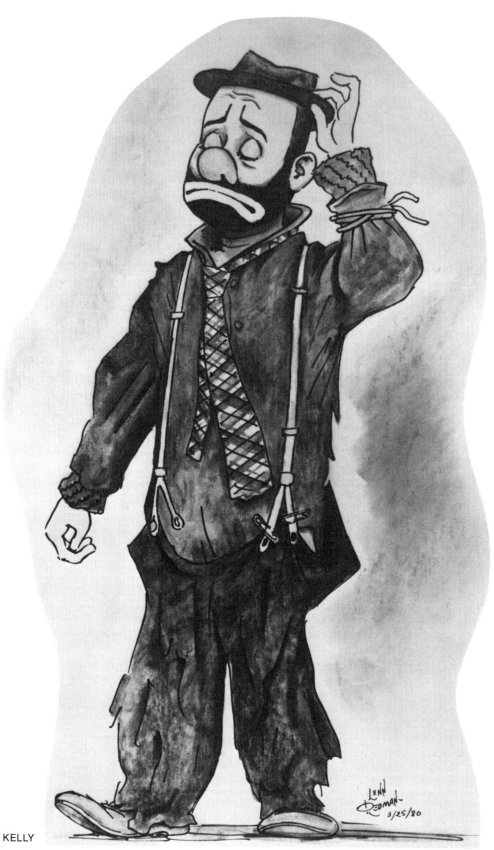

EMMETT KELLY

JERRY COLONA

WILL ROGERS

VICTOR BORGE

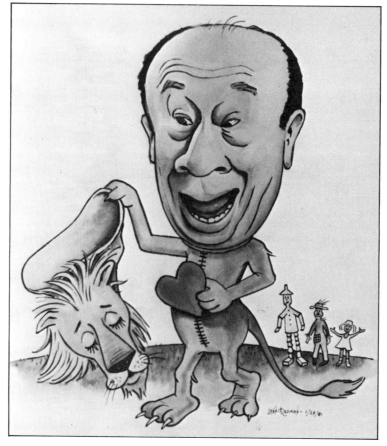

BERT LAHR

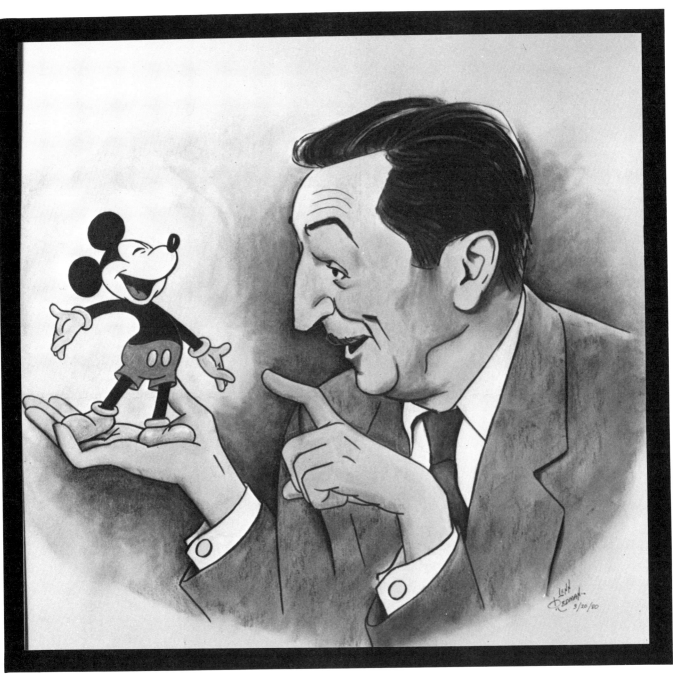

WALT DISNEY and MICKEY MOUSE

Experimenting with Styles and Techniques

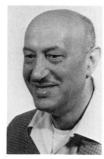

SOL

If you have ambitions to become a professional caricaturist, experiment with different styles of drawing and different techniques. Most periodicals have an art director. You should prepare yourself to meet whatever his requirements might be. Like everyone else, advertising art directors have their own likes and dislikes—one art director may be partial to a simple line drawing; another may prefer a more elaborate style. Also, an art director's request for a particular style of drawing is usually contingent on the type of advertisement he is preparing. An ad for perfume or women's lingerie would probably not call for a caricature. But if the art director did think it appropriate, he'd no doubt look for a caricaturist to draw it with a very delicate line. If the ad were for a hardware product, a heavier line would be more suitable.

There are occasional changes of technique and style throughout this book. I have done that to show you the many ways a caricature can be drawn. Try it. It's good practice, and it's fun to experiment.

Figuring out how to portray my friend Sol was an interesting and enjoyable exercise for me. This technique and the one on the next page are different from those shown so far.

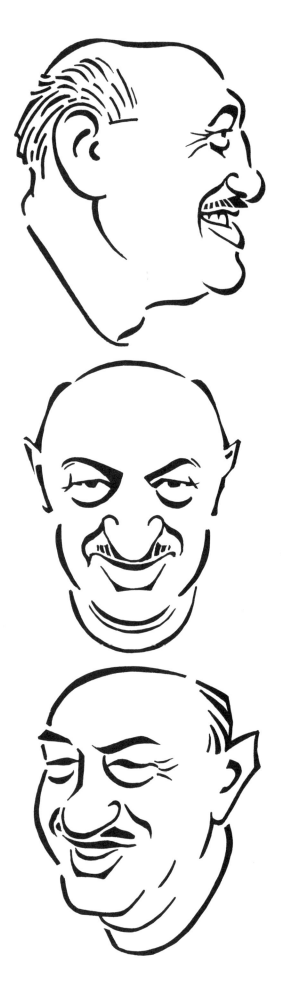

118

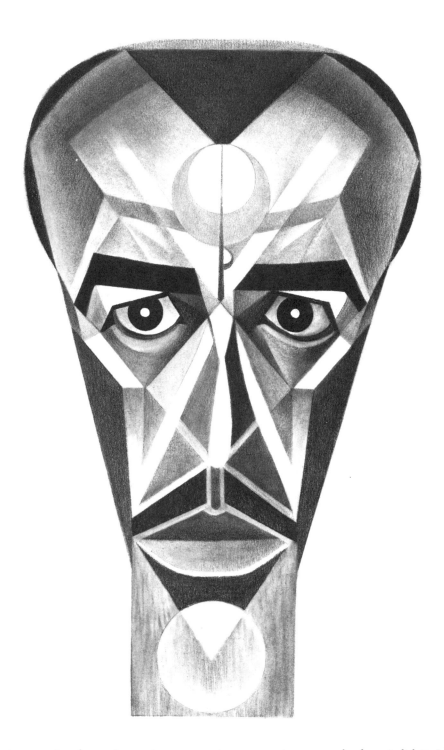

This caricature is of me. I was in a very strange, serious mood when I did it. I had a beard and mustache in those days.

IN THE STYLE OF IMPRESSIONISM

Since a caricature is an artist's exaggerated impression of a person, I think the fine art of *impressionism* warrants some explanation.

The great French Impressionists introduced a method of depicting things by means of dabs or strokes of primary unmixed colors in order to simulate reflected light. Though the resultant creations were factual, the individual objects in their paintings were vague. The impressionists knew that people do not see detail unless they specifically look for it; and when they do, the detail is not revealed enmasse but one segment at a time. For example, the hairs on one's head are not seen individually, nor are the leaves on a tree, or the trees in a forest, 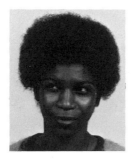 or the furniture in a room. All that is seen is the impression of their totality.

The impressionists did not paint exactly what they saw. They painted the impression of what they saw. Caricaturists do the same.

You probably know that impressions are subject to change. Do Ruby and Rochelle look familiar to you? A different impression of them is on page 36. All art hinges on interpretive impressions.

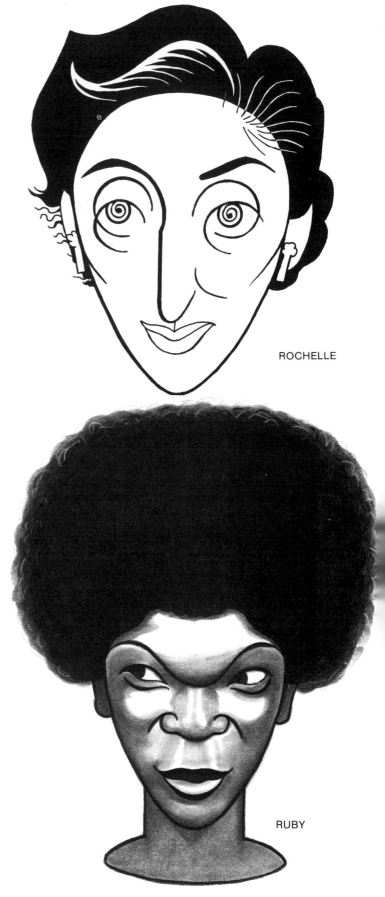

ROCHELLE

RUBY

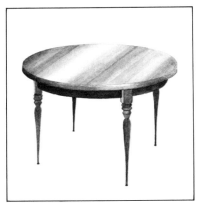

This is an abstract drawing—

of this table

CARICATURES AS ABSTRACT ART

I believe caricatures may also be categorized as *abstract art*. I don't mean the kind done by arbitrarily squeezing paint out of tubes or pouring it out of buckets onto canvas. Nor do I mean meaninglessly shaped forms and scribbles. Caricaturing is a controlled art requiring discipline. The kind of abstract art I refer to stems from one of the dictionary's definitions of *abstract:* "to take from; to pull out of; to reduce to the most essential elements." I believe that is what a sincere abstract artist does: he reduces things graphically to their simplest forms and abstracts from them the basic elements of a scene, quite often to the exclusion of most everything else. The drawing of the table abstracts its basic elements: its roundness and

its four legs. Because perspective has nothing to do with the physical essence of the table, it likewise has been eliminated. Extraneous lines and forms may be incorporated in a drawing or painting, but it is the emphasis of its basic elements in the simplest way that makes it an abstract representation.

The caricature of James on page 102 is a good example of a simplified abstract impression of a person. It abstracts only those features that make the drawing of James recognizable. This caricature is another one—it's of me as I looked many years ago. I used it as a logo on my business cards and stationary. Later as I began to lose hair I decided it would make a better design to remove the hair completely. I used a bit of surrealism in the drawing by incorporating my name in the mustache.

The last drawing of John L. Lewis on the next page is a more detailed and complicated impressionistic abstraction.

LENN REDMAN CARTOON ATTRACTIONS

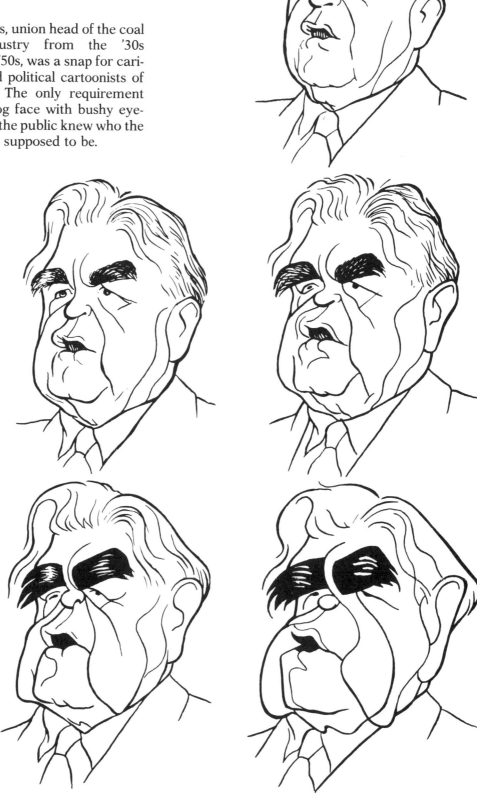

John L. Lewis, union head of the coal mining industry from the '30s through the '50s, was a snap for caricaturists and political cartoonists of that period. The only requirement was a bulldog face with bushy eyebrows—and the public knew who the drawing was supposed to be.

IMPRESSIONISM, ABSTRACTION, EXAGGERATION—TO WHAT EXTENT?

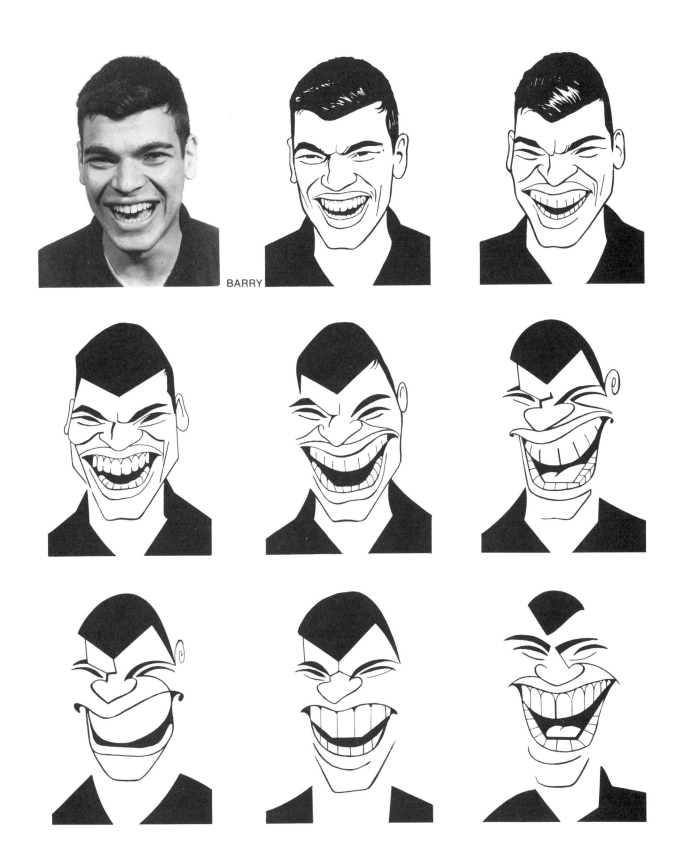

BARRY

His characteristic smile, protruding chin, and the tilt of his head and cigarette holder were all that were needed to identify President Franklin Delano Roosevelt.

At the very beginning of this book I referred to distortion as being a denial of truth. That it is—but there are different kinds of distortion. The last drawing of John L. Lewis on page 122 and the last four drawings of Barry on page 123 are distortions of fact, but they may still be regarded as caricatures. They have not been distorted purely for the sake of distortion, as is often seen in paintings commonly referred to as abstract art. The distortion of Mr. Lewis's face and Barry's face are the result of their successively increased exaggerations. I doubt that many people would recognize the last drawings of either man if they had not been conditioned by seeing the gradual transition from the previous ones.

Caricatures by Robert Grossman. Reprinted from cover of *Newsweek*, January 12, 1976.

Some of our greatest editorial cartoonists lack the ability to draw good caricatures, but they get along by using this conditioning process on their readers. During Jimmy Carter's administration, all they needed to draw was a tremendous grin on a character representing him and the viewers of the cartoon accepted it as being Mr. Carter whether it looked like him or not. The same was true of Gerald Ford. The public was conditioned into accepting a bald head and a tremendous space between nose and mouth as representative of him. Likewise with Ronald Reagan—a large, well-groomed head of hair and a wrinkled face does the trick.

The recognizability of the excellent caricatures of Presidents Ford and Reagan above was accomplished without the need for public conditioning. I couldn't find a good caricature of President Carter to show you. The only ones I have of him are with closed, laughing eyes. Mr. Carter's eyes almost always remain open when he grins.

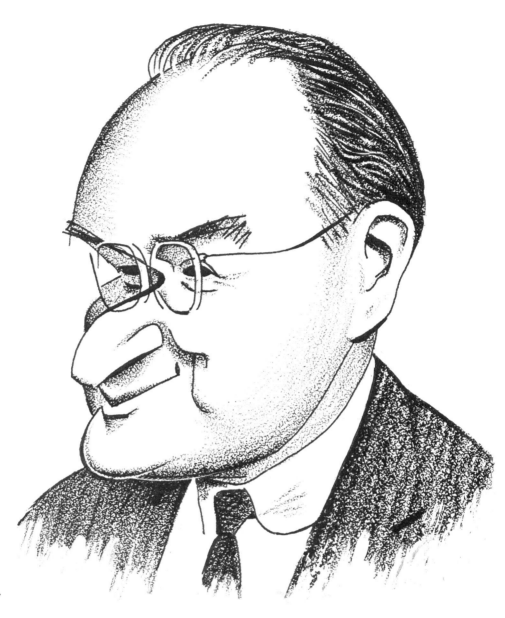

A wee bit of abstract impressionism. This distorted likeness has been drawn directly, skipping the gradual increase in exaggeration shown in the caricatures of John L. Lewis and Barry on pages 122 and 123.

WILLIAM

SYMBOLIC CARICATURES

A likeness of a person is portrayable symbolically. You can draw a loving person out of a heart, a pacifist out of a dove, a wise person with the features of an owl, an evil person out of a serpent, an American patriot with stars and stripes in his face, a clergyman out of the symbol of his religion.

My caricature of John D. Rockefeller, above, was inspired by the fact that he was reputed to be the richest man alive. He was sickly during the latter part of his life and was compelled to live on baby food—but I thought it would be funnier if I drew him nibbling on the stem of the dollar sign.

The USSR red star and hammer and sickle inspired me to draw premier Leonid Brezhnev out of those symbols.

The particular symbol a caricaturist chooses to portray his subject is often based on personal bias or prejudice. In 1834 Charles Philipon, cartoonist and editor of *Charivari*, drew King Louis Philippe of France as a pear. In four stages, over a lengthy period of time, he had gradually conditioned his readers into accepting the pear as a likeness of the king. The king didn't see anything funny about it. He made Philipon sweat plenty in the courts.

Herbert Hoover happened to be President of the United States during the great depression. This drawing of his likeness on human buttocks reflects the general hatred of him at the time.

Herbert Hoover
Artist: Nordley
Published 1932

I don't think this artist liked President Franklin D. Roosevelt very much. Why else would he have made a melonhead out of him?

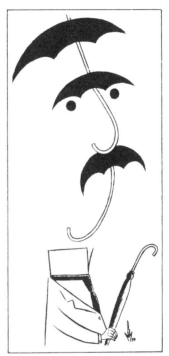

Appeared in *Nebelspalter*, Zurich, 1938.

Prime Minister Neville Chamberlain was usually seen with an umbrella. When he attempted to mollify Adolf Hitler by conceding Czechoslovakia to Germany, both he and the umbrella became the symbol for appeasement.

The elephant symbolizes the Republican Party. Political cartoonist Paul Conrad was thinking along the same lines as Nordley when he drew this caricature of Ronald Reagan for the *Los Angeles Times* during the 1980 presidential campaign.

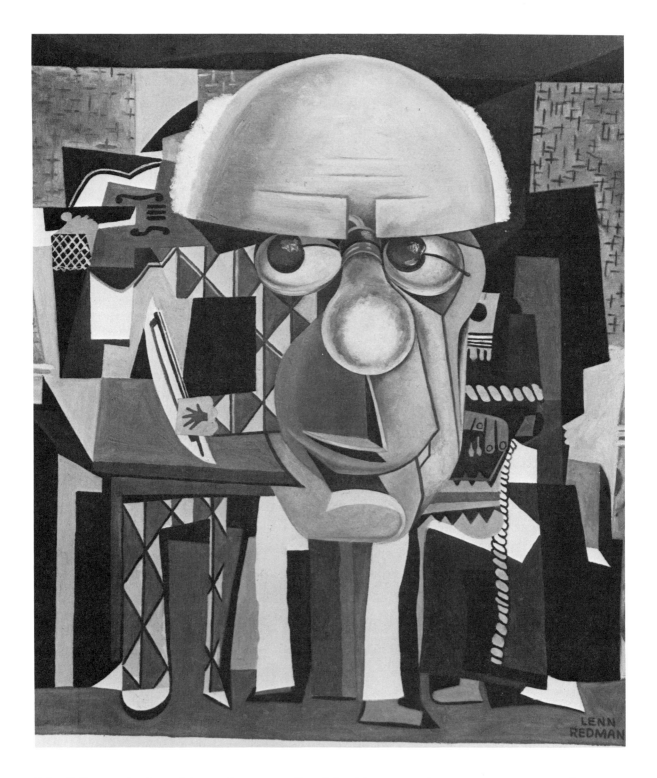

I had fun painting this caricature of Pablo Picasso. It's impressionistic, abstract, surrealistic, and symbolic—all wrapped into one. The original is 17" × 20" in brilliant, full-color oil paint. The background is copied from a creation of his own entitled "Three Violinists." Mr. Picasso was an extremely virile man, even in his later years. I gave him cherries for eyes because of his propensity for young women.

A Sampling of Success

And now to show you a few caricatures from my prized collection of beautifully designed caricatures by other artists. Many of the clippings are from 40 to 50 years old; in spite of my having mended and retouched the most damaged ones, a few of them show their age. Nevertheless, I believe their artistic excellence, uniqueness, and historical significance warrant my sharing them with you.

With the exception of David Low, Ronald Searle, Robert Grossman, and Paul Conrad (pages 81, 82, 124, 127, and 145) whose works are featured because they show qualities not specifically dwelled upon elsewhere in this book, I have not included the work of other renowned present-day caricaturists such as Mort Drucker of *Mad Magazine*, who does marvelously satirical movie review comic strips, and who is most certainly worthy of mention. The wonderful caricatures of Roman Lurie, D. Levine, and Al Hirschfeld frequently appear nationally in newspapers and magazines. And if three recent imports from France are not known to you, I think they soon will be: Patrice Ricord, Claude Morchoisne, and Jean Mulatier.

It is my intent to keep alive the names of caricaturists who reigned supreme during the early part of my career and earlier. I learned much from them. They inspired me. I hope the inclusion of their work in this book has the same effect on you. The artist I admired most was Miguel Covarrubias. What a pleasure it was to behold his exquisite designs and masterful combinations of color—he was so joyously innovative! I think it was he who first incorporated such bizarre designs in his caricatures as (to name only a few) spiral eyes and eyes protruding outside one's head, and a side view nose on a front view face. The marvel was that in spite of what he did, he managed to retain a likeness. Every once in a while *Vanity Fair* would run a two-page spread of his work. The one I've chosen to show you is a portrayal of Franklin Delano Roosevelt's inauguration. A key to the dignitaries in it is on page 166.

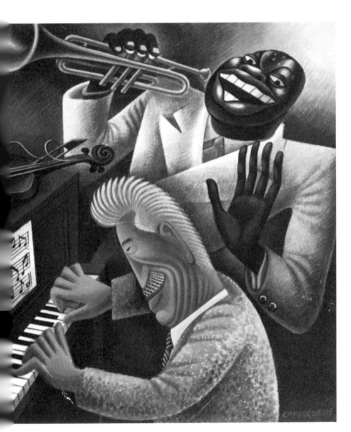

FRITZ KREISLER and LOUIS ARMSTRONG, *by COVARRUBIAS, FEBRUARY, 1932*
© by the Condé Nast publications, Inc.

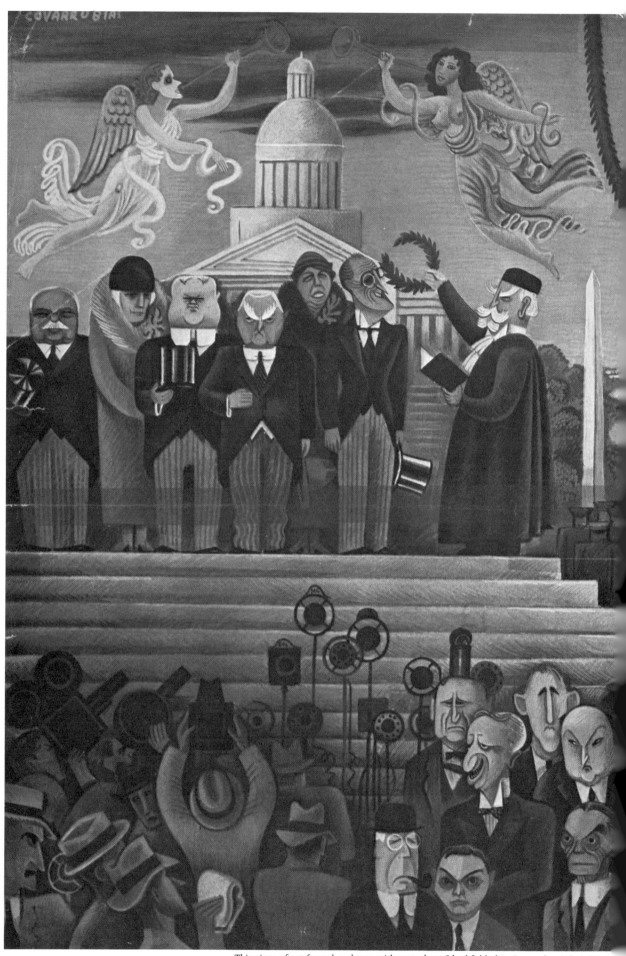

This piece of art frayed and tore with age where I had folded it. Sorry about that, Migu

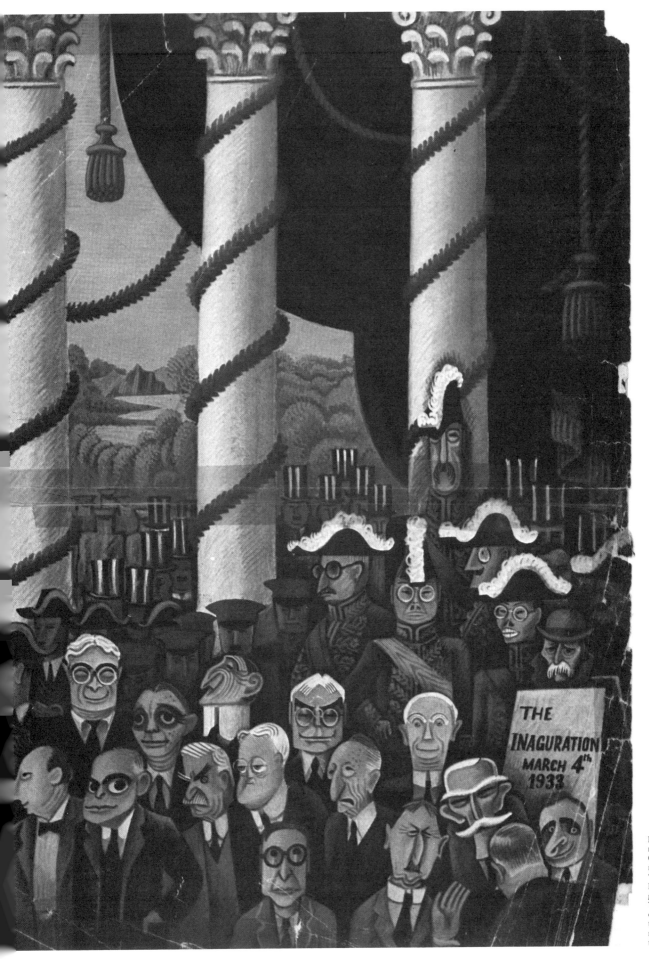

THE INAGURATION MARCH 4th 1933

I was pleased to notice that Covarrubias misspelled "inauguration." It puts me in good company. Thanks to my editor, this thesis is readable—I'm a terrible speller.

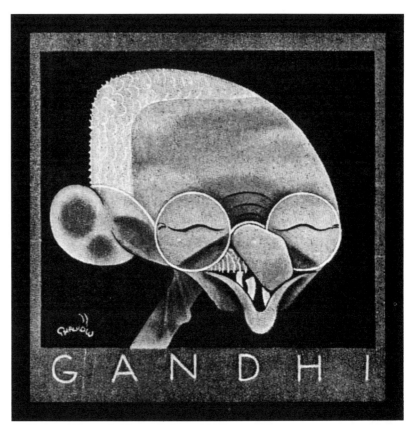

MOHATMA GANDHI

These two ingeniously designed caricatures are by Carl Berglow. They're from a German-American paper called *Illustreret Familie-Journal.*

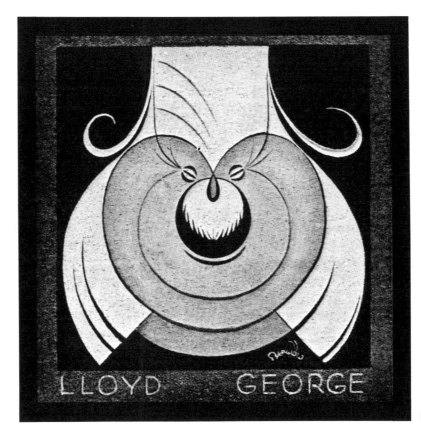

LLOYD GEORGE

J. Ramsey McDonald was Prime Minister of England when this caricature of him was drawn by Scheel.

This caricature of then U.S. Ambassador Andrew Mellon was drawn by Scott Johnston.

134

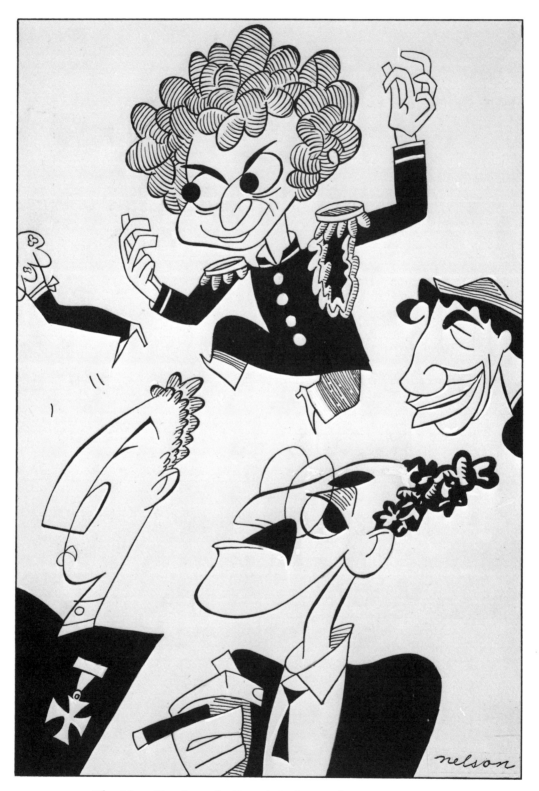

The Marx Brothers, by Roy C. Nelson, *Chicago Daily News.*

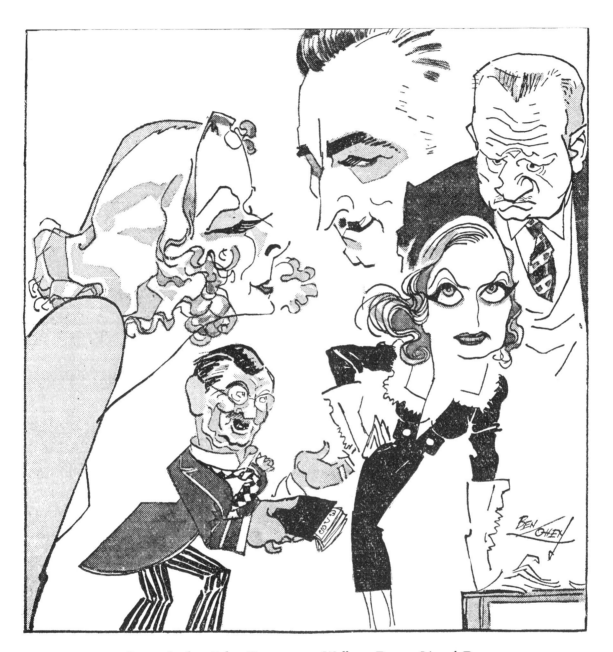

Greta Garbo, John Barrymore, Wallace Beery, Lionel Barry-
more, and Joan Crawford as they appeared in the motion
picture, *Grand Hotel*.
Ben Cohen, *Chicago Tribune*.

136

Lillian Gish
by Ralph Barton,
Chicago Daily News, April 3, 1941

Cab Calloway
by Hod Taylor,
Chicago Daily News, 1941

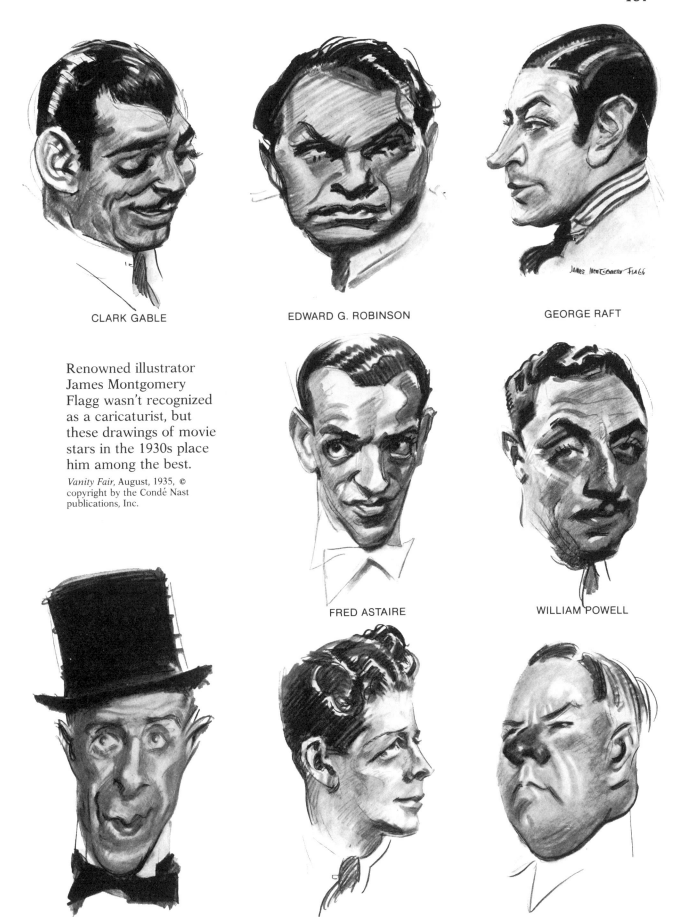

CLARK GABLE

EDWARD G. ROBINSON

GEORGE RAFT

Renowned illustrator
James Montgomery
Flagg wasn't recognized
as a caricaturist, but
these drawings of movie
stars in the 1930s place
him among the best.

Vanity Fair, August, 1935, ©
copyright by the Condé Nast
publications, Inc.

FRED ASTAIRE

WILLIAM POWELL

CHARLES BUTTERWORTH

RUDY VALLEE

W. C. FIELDS

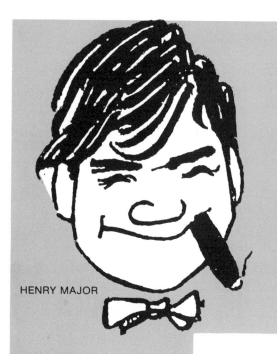

HENRY MAJOR

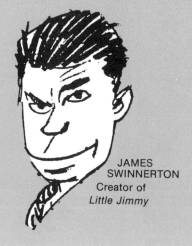

JAMES
SWINNERTON
Creator of
Little Jimmy

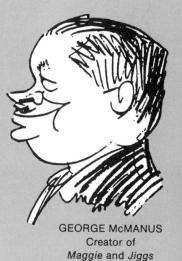

GEORGE McMANUS
Creator of
Maggie and *Jiggs*

Nostalgia prompted me to share these excellent drawings with you by Henry Major. They're of just a few of the many cartoonists whose work brought me such pleasure in my youth. Major's self-caricature reveals how young he was when he drew them.

HARRY HERSHFIELD
Creator of
Abie the Agent

BILLY
De BECK
Creator of
Barney Google

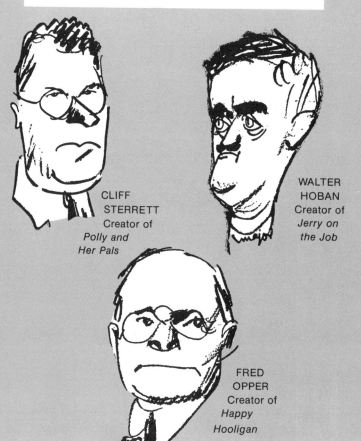

CLIFF
STERRETT
Creator of
*Polly and
Her Pals*

WALTER
HOBAN
Creator of
*Jerry on
the Job*

RUSSELL WESTOVER
Creator of
Tillie the Toiler

FRED
OPPER
Creator of
*Happy
Hooligan*

T. A. (TAD)
DORGAN
Creator of
Indoor Sports

ADMIRAL BYRD WINTERS IN TAHITI

HUEY LONG ENTERS A MONASTERY

J. P. MORGAN BECOMES A SOAPBOX ORATOR

DRAWINGS BY GROPPER

JAPAN'S EMPEROR GETS THE NOBEL PEACE PRIZE

WILLIAM RANDOLPH HEARST IS APPOINTED AMBASSADOR TO THE SOVIET

Not on your tintype

Five highly unlikely
historical situations
by one who is sick of
the same old headlines

Artist: William Gropper
Published in *Vanity Fair*, August, 1935,
© copyright by the Conde Nast Publications, Inc.

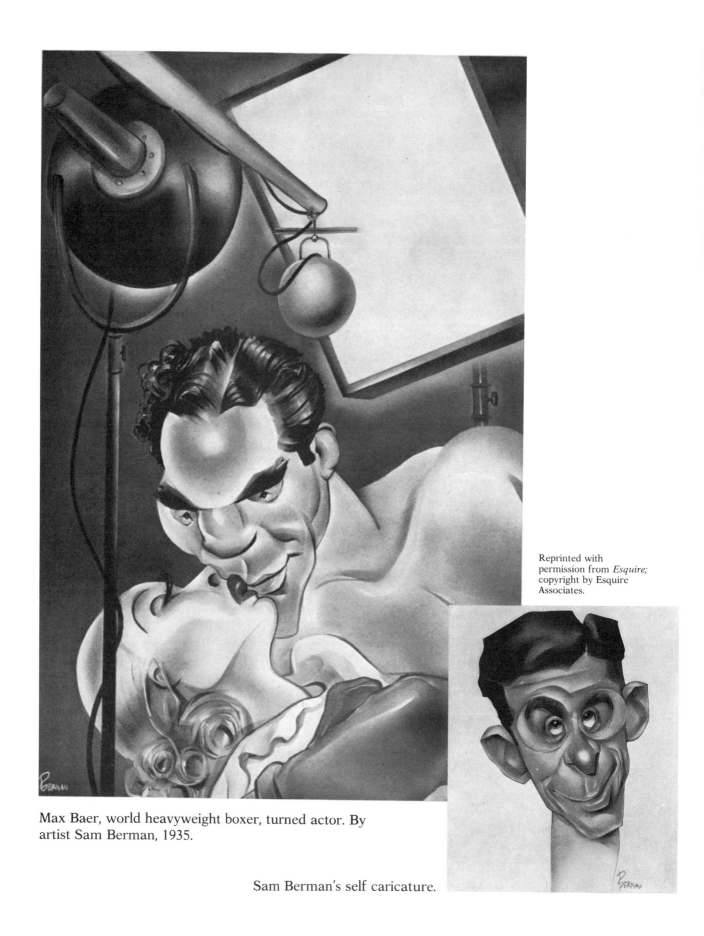

Max Baer, world heavyweight boxer, turned actor. By artist Sam Berman, 1935.

Sam Berman's self caricature.

This drawing of New York's Mayor Fiorello Henry La-Guardia is by Sebastian Robles. It was rendered on a pebbly scratchboard. It won first prize in a caricaturing contest given by *Art Instruction* magazine of Watson-Guptill Publications in 1938. Mayor LaGuardia was a powerful, forceful, and voluble man. This drawing leaves no question about it.

Renowned caricaturist William Auerbach-Levy, whose drawing of composer George Gershwin is shown below, was one of the judges.

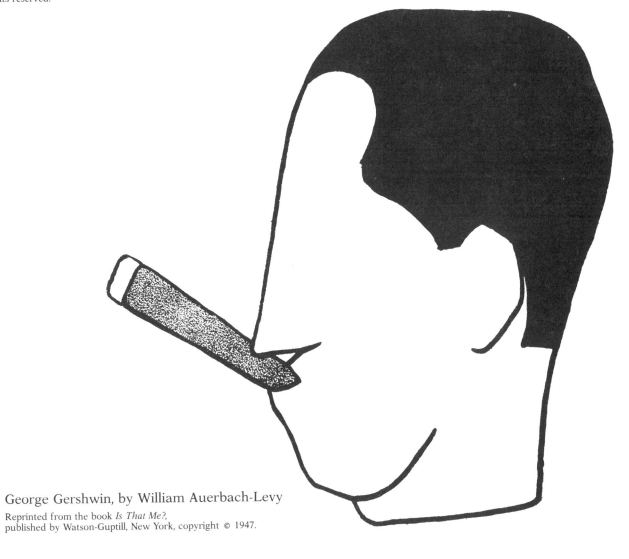

George Gershwin, by William Auerbach-Levy

142

Caricatures by Salazar
Appeared in *Vanity Fair*
© copyright by the Condé Nast
Publications, Inc., October, 1931

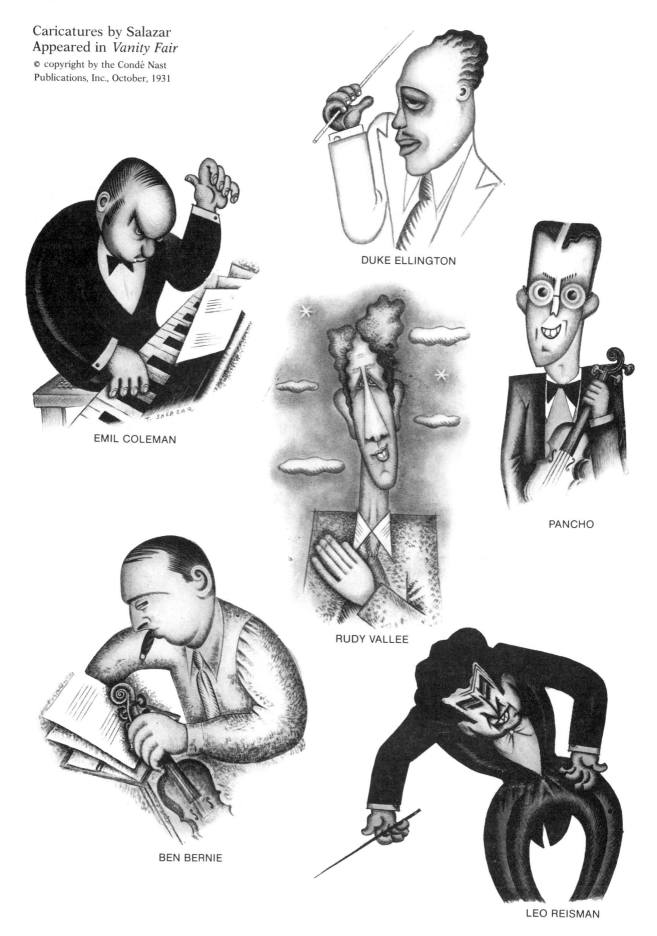

DUKE ELLINGTON

EMIL COLEMAN

PANCHO

RUDY VALLEE

BEN BERNIE

LEO REISMAN

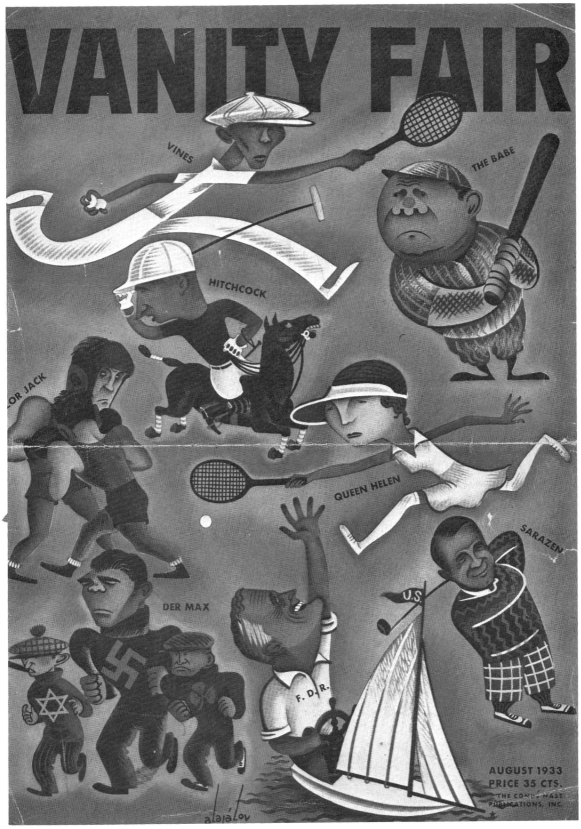

Illustrated by Alajalov—copyright © 1933, renewed 1960 by Condé Nast Publications, Inc.

This was a typical *Vanity Fair* cover. The originals, size 9″ × 11¾″, were always beautifully designed in full color.

Notice the price. You can't get a cup of coffee for that now.

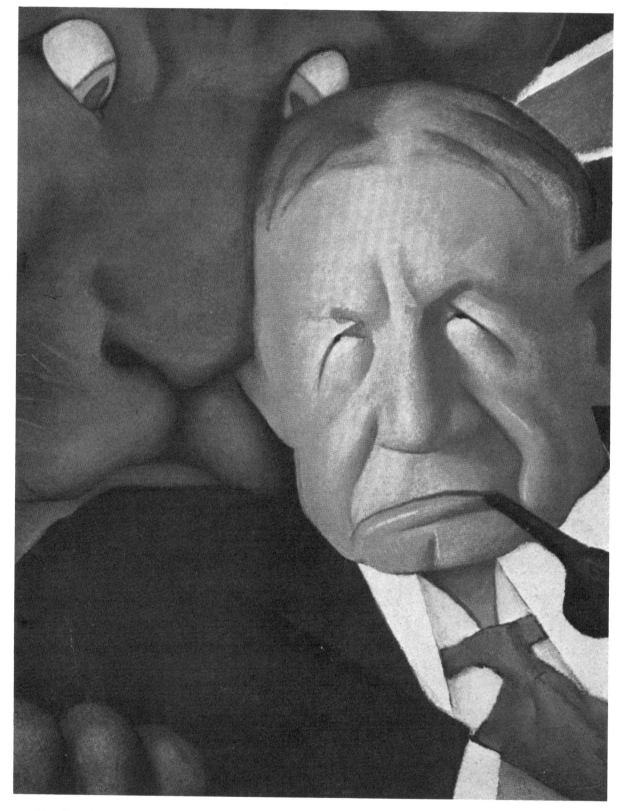

Charles G. Dawes, ambassador to Great Britain under President Herbert C. Hoover, is caricatured by William Cotton in pastels.

Vanity Fair, January, 1932, copyright © Condé Nast Publications, Inc.

Most caricatures by other artists in this book are self-explanatory.

However, my presentation of these caricatures of Premier Nikita Krushchev and President John F. Kennedy by English caricaturist Ronald Searle require explanation. The drawings originally appeared separately, and at different times. The one of Nikita Krushchev, printed in full color, occupied a full page in *Holiday* magazine sometime during Krushchev's premiership. The drawing of John Kennedy was one of several Mr. Searle sketched with obvious rapidity as he covered Kennedy's presidential campaign.

The hostile expressions Searle put on both men's faces and Kennedy's extended clawing hand reminded me of the Cuban missile crisis, during which they were at loggerheads with each other. It's what prompted me to set the drawings together as a single illustration.

PADEREWSKI

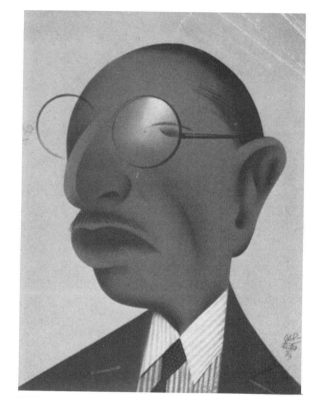

STRAVINSKY

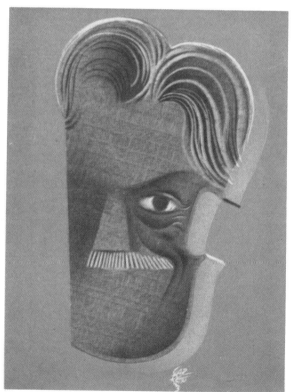

KREISLER

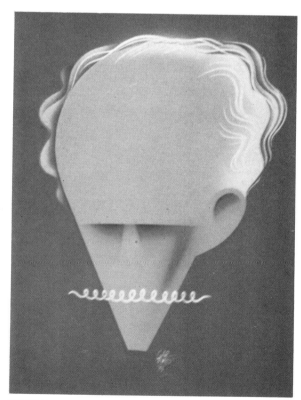

TOSCANINI

Artist: Gar/Etto, published in *Vanity Fair*, March, 1934

Queen Wilhelmina of the Netherlands, abdicated in 1948

Two entirely different caricature techniques of two entirely different types of people—both by Schoukhaeff in *Vanity Fair.*

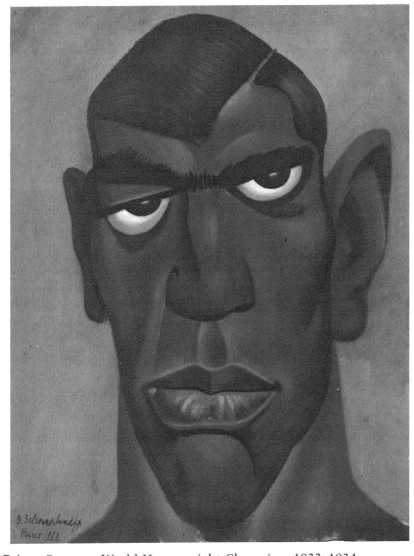

Primo Carnera, World Heavyweight Champion, 1933–1934

CARICATURE VARIATIONS

Babe Ruth by Ralph
Reichold, Pittsburgh, PA

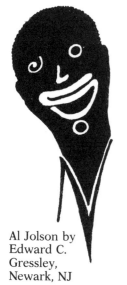

Al Jolson by
Edward C.
Gressley,
Newark, NJ

Paul Whiteman by K.
H. Day, Cambridge, MA

If you know how to type, see if you can duplicate
this one.

Irving Berlin by H.
W. Smith, Elkins, WV

Drawing something out of a person's name is an
old chalk-talk stunt. I used to do it occasionally
myself. There are simple and easy tricks to it. But
to achieve a caricatural likeness with the letters
of a person's name in correct alphabetical
order—that's something else! These are ex-
tremely clever.

Will Rogers by R.
Sweitzer, St. Paul, MN

These caricatures are not what they appear to be. They were drawn (maybe painted) to simulate wood carvings with metal trim by *Chicago Sunday Tribune*'s staff artist George F. Lundy. Published June 24, 1934.

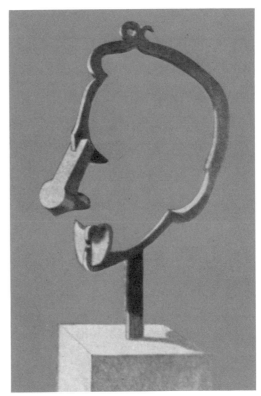

JIMMY DURANTE

GEORGE ARLISS

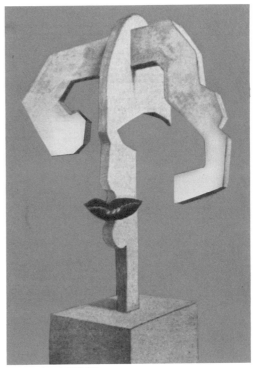

JOAN CRAWFORD

149

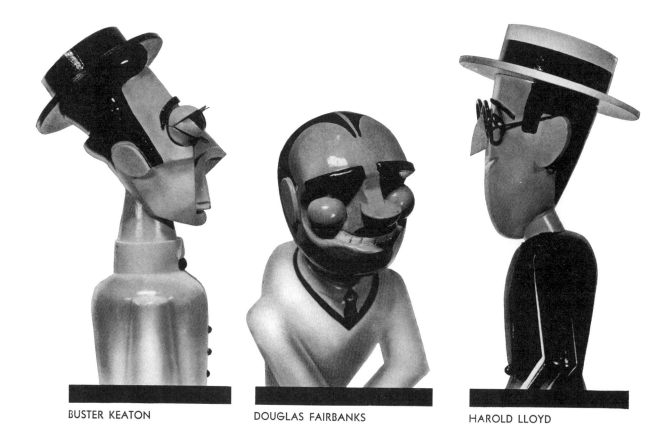

BUSTER KEATON

DOUGLAS FAIRBANKS

HAROLD LLOYD

Hollywooden celebrities

Carved, planed, and highly polished wood caricatures of yesteryear's film stars by Parisian artist Nikolaus Wahl.

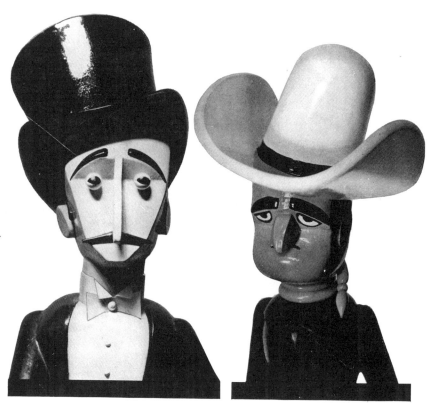

ADOLPHE MENJOU

TOM MIX

PHOTOGRAPHS BY HOYNINGEN-HUENÉ

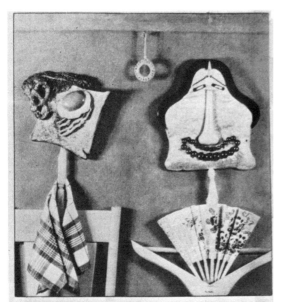

Three-dimensional caricatures out of food and diverse objects by Lou Hirshman. Reproduced from *Look* magazine, May 10, 1938.

Wally and Her Duke through the eyes of Hirshman. The Duke's head is made of toast, a fried egg and bacon, a pretzel and a leaf of spinach. The food is especially treated to prevent its spoiling. Wally consists of a pocket book, a bone pin, beads, safety and bobby pins. Her body is made of a fan and a clothes hanger. To the left is a photograph of the couple.

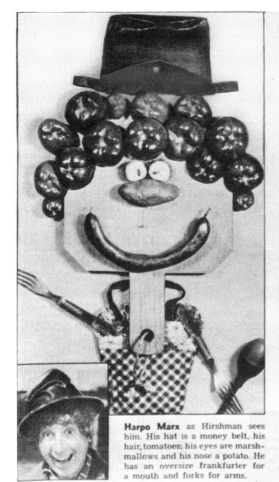

Harpo Marx as Hirshman sees him. His hat is a money belt, his hair, tomatoes; his eyes are marshmallows and his nose a potato. He has an oversize frankfurter for a mouth and forks for arms.

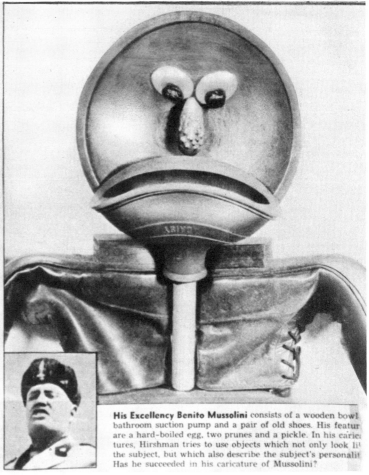

His Excellency Benito Mussolini consists of a wooden bowl, bathroom suction pump and a pair of old shoes. His features are a hard-boiled egg, two prunes and a pickle. In his caricatures, Hirshman tries to use objects which not only look like the subject, but which also describe the subject's personality. Has he succeeded in his caricature of Mussolini?

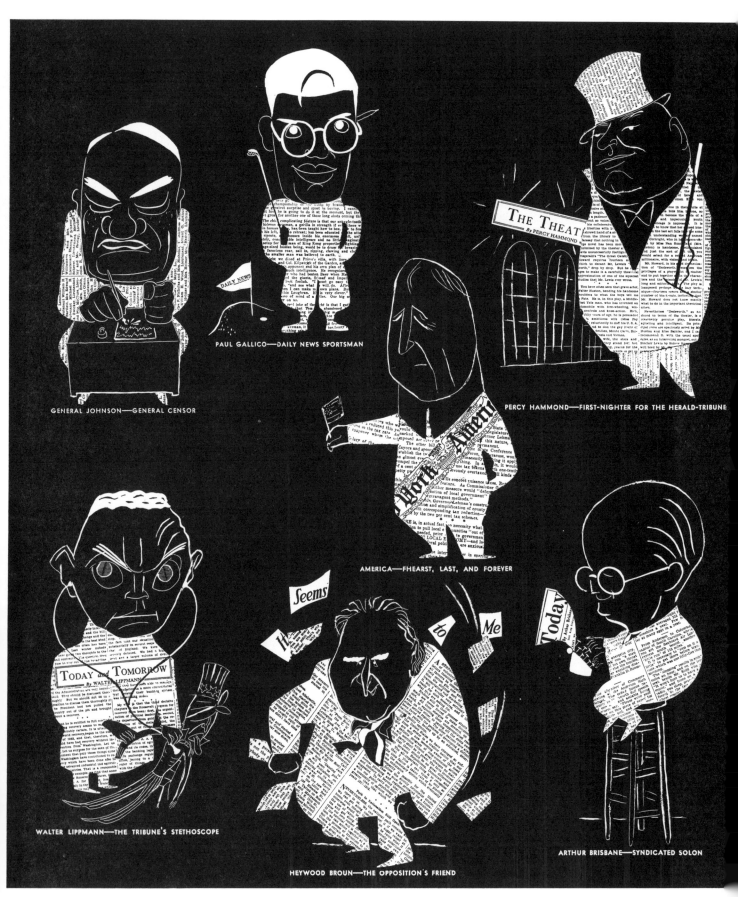

GENERAL JOHNSON—GENERAL CENSOR

PAUL GALLICO—DAILY NEWS SPORTSMAN

PERCY HAMMOND—FIRST-NIGHTER FOR THE HERALD-TRIBUNE

AMERICA—FHEARST, LAST, AND FOREVER

WALTER LIPPMANN—THE TRIBUNE'S STETHOSCOPE

HEYWOOD BROUN—THE OPPOSITION'S FRIEND

ARTHUR BRISBANE—SYNDICATED SOLON

Famous writers and reporters of their day by Alain, published in *Vanity Fair*, May, 1935.
Copyright © (1935) renewed 1963 by Condé Nast Publications, Inc.

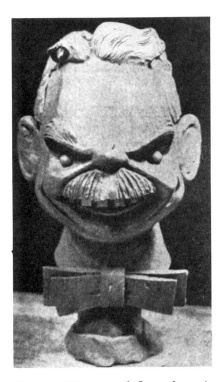

Thomas E. Dewey, defeated presidential candidate against Harry S. Truman by Carol Johnson.

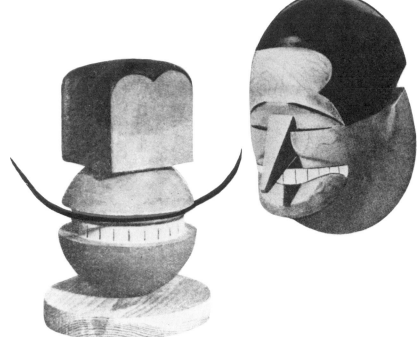

Planed and carved wood sculptures of movie actors Douglas Fairbanks and Maurice Chevalier. *Illustreret Familie–Journal.*

I could go on and on with the wonderful caricatures in my collection. I have chosen these particular ones because they show the large variety of styles, techniques, and media with which they were created. I hope they inspire you as they inspired me. (And still do.)

Back to my friends. I want you to see how they look caricatured from other views.

HERE THEY ARE.

The number beside each caricature indicates the previous page on which my friends appear.

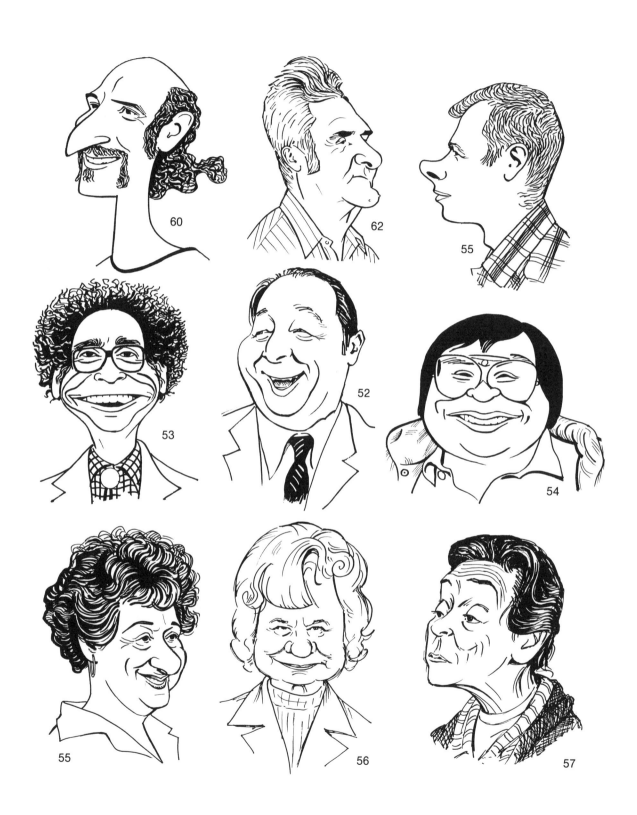

60

62

55

53

52

54

55

56

57

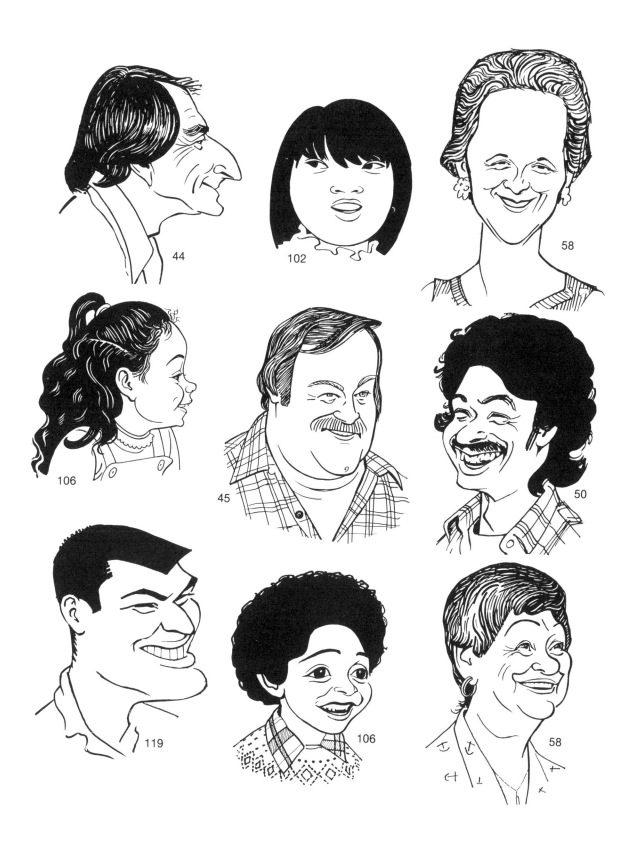

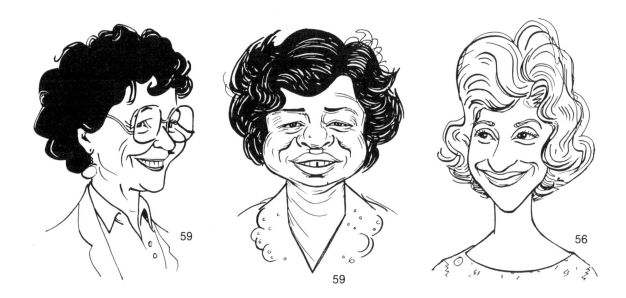

59

59

56

That's it! I have no more drawings of my friends to show you. Nor can I think of anything more to teach you about caricaturing. The rest is up to you. I've enjoyed writing this book, but I regret not being with you to share your pleasure each time you capture someone's likeness. Have fun! I wish you well.

FINIS

What Am I?

A 12-verse poem expounding the beauty and virtue
of human diversity.

by
LENN REDMAN

160

What Am I?
I am People, that's what I am.
I am man, woman, child and infant.

I am an endless variety of dissimilarity on parade
to be looked upon with respect.
The time is over for the masquerade.
Cast off your garments and reflect.
You're in the picture too;
don't ever forget.

What a face I have!
It varies in size, texture, shape and slope,
Like that of a cactus, gourd and cantaloupe.

My eyes, nose, mouth and ears
are large, small, long, short,
flat, bulbous, narrow and wide.
And the spaces between my features
are as varied as the features themselves.
It has been said they show my soul,
those organs called eyes—
which bulge, recede, droop, squint, glare and dart,
and are round, narrow, slanty, close together
and far apart.
Of course they show my soul, my eyes,
but no more so
than the top of my head or the orbs in my skies.

And I Am Multicolored.
I am a peculiar hue
of red, yellow, white,
black, brown, tan, gray,
pink, bronze, copper, gold
and a thousand shades of each.
I am as united
By the spectrum of my different colors
as the planets are united
by their orbital relationships.

What if I had been born red, white, black and yellow?
I mean Really red, white, black and yellow—
and blue and green and orange and purple
and checkerboard and plaid and candy-striped
and polka-dot and herringbone, and—
oh, who knows what else?

I am what I am
And I must know what I am
For some day
I will see myself from other planets
And who knows what I will see?

I will see
that there are more differences to my makeup
than I've ever imagined.
Is there the slightest possibility
I'd accept myself with objectivity,
if not goodwill and mirth
Before I've purged myself of all hostility
to what there is of me right here on earth?

I am a symbiotic temple of seeming contradictions,
partial understanding of which may be had by asking questions.
Once the answers are known, man will begin to tower.
Is there a similarity between the bee and the flower?
Is black any more different from white
than white is different from black?
Is a peg any more different from a hole
than a hole is different from a peg?
And what of the circle, square and triangle,
the three most opposite geometric forms
Is one more different from the others
than the others are different from the one?
The answers, of course, are no; and That is their commonality.
The flower and the bee are not at all alike,
yet they thrive on each other's existence.
And black and white make a thousand beautiful shades of gray.
And a peg and a hole may effectuate a strong, inseparable bond.
And a circle, square and triangle
constitute the architectural foundation
for my temple of universal design.

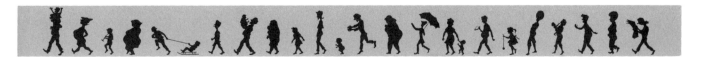

162

What Am I?
I am a rhapsodic symphony of differences.
But my differences are not individually more
unique than their respective counterparts.

I am a throbbing, pulsating spirit
always on the move, always changing,
interplaying with and reacting to
the various components of my whole.
They comprise infinite semblances
that are as varied and different
as night and day.
Yet from Infinity's vantage
night and day are the same.

What Am I?
I am the glow in flight.
I am it and it is I,
and You and I and It are One.
I am That, I AM.

© *Lenn Redman*

This poem, generously illustrated by Lenn Redman, is available as a 20-page book. Its cover and 7 of its pages are in full color. The pages are separated by transparent sheets to protect the illustrations, which are suitable for framing. The book is autographed by Lenn Redman.

To order, send $5.95 in check or money order for each copy requested to Mark Victor Publishing Co., 10855 Whipple Street, Suite 207, North Hollywood, California 91602. California residents add 6½% state sales tax. Shipment to Europe requires about six weeks.

Appendix:
Caricature Identifications

Page		Name			Name
10		Rosemary Tharps		47	Mary Borzelli
11		Doris Triffler		48	Virginia M. Green
14	1	W. E. B. Dubois		49	James W. Teegarden
through	2	Lucy Figueroa		50	George Kennedy
15	3	Theron Brown, Jr.		51	Judi Sturdevant
	4	Dottie Due		52	Dennis Merritt
	5	Glenn Ytzen		53	Charlene Rutchland
	6	Marie Chinnici		54	Peter J. LaPlaca
	7	Chairman Mao Tse Tung		55	Linda M. Howard
	8	Marion C. Robison		56	Emil Parque
	9	Lillian Leavitt		57	Gail Polin
	10	Barbara Wezereck		58	Elsie S. Mungerson
	11	Dr. Richard R. Drisko		59	Anneline Liu
	12	Dave Callahan		60	Carol A. Dorse
	13	Lynne Stout		61	Bill Cosby
	14	Victor Solomon		62	Patti Bauer
	15	Mildred Linhoff		63	Premier Nikita Khrushchev
	16	Myron Baker		64	Joe Vann
	17	Pat Chelius		65	Dave Beck
	18	Zita M. Drake		66	Loren Mages
	19	J. Bruce Duncal		67	Nancie K. Mages
	20	Dame Sybil Thorndike		68	Burnette Williams
	21	Gladys Moss		69	Jackie Anders
	22	William N. Kotowicz		70	Linda Merrill
	23	Jeanne Peahl		71	President John F. Kennedy
	24	Pope John XXIII		72	Maggie Enderle
	25	Jerry Hutcheson		73	Kathy Clinker
	26	Prime Minister Golda Meir		74	Dennis McClain
	27	Ralph N. Hahn		75	Nip Guest
	28	Marilyn Monroe		76	Pat Millar
	29	Jack Olevsky		77	Nate Smith
	30	Gordon Shultz		78	Robert E. Inman
	31	Elyzabeth Smith		79	Premier Chow En-Lai
	32	Hal Sutherland		80	Allan Preston
	33	Carol Robertson		81	Lillian Cole
	34	Louis Meltzer		82	Jean Leuis Barrault
	35	Phyllis Horton		83	Genevieve Loprino
	36	Ed Bunch		84	Helen E. Wilcox
	37	Sophie Tucker		85	Jerry Feldman
	38	Loretta Kappa		86	Amy Greenwood
	39	Jimmy Durante		87	Marion Turk
	40	Jo Ann Linder		88	Dick Gregory
	41	Cliff Linder		89	Beatrice R. Levin
	42	Claudia Hebenstreit		90	Yves Montand
	43	Eirik Knutzen		91	Renee Henning
	44	Catherine Boucher		92	Linus Pauling
	45	Ralph W. Zeigler		93	Jim Everly
	46	Dave Bunch		94	Russel Wadle

continue
page 15

95 Ruth A. Rehberg
96 Laurence Silverman
97 Simone Signoret
98 Jose Galvan
99 Elizabeth Nakano
100 Addy Green
101 Mary Ewing
102 Helen Stevens

Page
16
through
17

1 Mary M. Bechtold
2 Carolyn Yarbough
3 Henry W. Stricker, Jr.
4 Maria Ordonez
5 Robert Oppenheimer
6 Janice Linder
7 Hank Santana
8 Edwina Clavey
9 Ray Saunders
10 Grace M. Detloff
11 James Eric Yates
12 Ida M. Cox
13 Louis Armstrong
14 Alvizio C. Lage
15 Martin Luther King, Jr.
16 Carl Sandburg
17 Sheila Tomoi
18 Sophie F. Frisbie
19 Johanna Mayr
20 Nancy Nishimura
21 Silas S. Cathcart
22 Virginia M. Weber
23 Art Rogers
24 Jeanne K. Goodman
25 Lew Benvenuto
26 Eileen Spradlin
27 Joyce Simmons
28 Hershey Bassett
29 Diane Porche
30 Bill I. Johnson
31 Lianna Kelley
32 Aristotle Onassis
33 Llola Bankins
34 Vittorio de Sica
35 Dan Stanffer
36 Robert A. Gordon
37 Jonathan Mahlanza
38 Fred W. Otto
39 Laurentia Wycoff
40 Ralph Abernathy
41 Duchess of Windsor
42 Ronald Troka
 Virginia Lanham

44 Emil J. Koe
45 Frances M. Kempk
46 Reverend Silas Hong
47 Ben Rodrique
48 Dorothy Chin
49 Celeste Morrow
50 Sammy Davis, Jr.
51 Lord Bertrand Russell
52 Aida Gomez
53 Norman Bercuson
54 Lorraine Hoppe
55 Daniel Dombrosky
56 Dorothy Ginther
57 Edward Lotz
58 Marie W. Kroepfl
59 Bob Touchstone
60 Frederic E. Gore
61 George Meany
62 E. T. Credle
63 James Baldwin
64 George A. Giotis
65 Dr. Albert Einstein
66 Christine L. Sharfe
67 Jacques Tati
68 Mahalia Jackson
69 Susan McMullen
70 James L. Garfield
71 Michelle Chew
72 James L. Coulter
73 Betty de Vogelaere
74 Paul Huffaker
75 Christie Parque
76 Michael Kinney
77 Audrey A. Finger
78 Marlo Thomas
79 Redd Foxx
80 Barbra Streisand
81 Carroll O'Connor
82 Burt Reynolds
83 Donna Giles
84 Leith E. Hayward
85 George Kary
86 Sally Struthers
87 Dick Cavett
88 Zsa Zsa Gabor
89 Liza Minnelli
90 Robert Redford
91 Nathaniel Clark
92 Kathryn Tope
93 E. C. Richards
94 Hedda Anders
95 Sir Charles P. Snow

KEY TO PRESIDENT ROOSEVELT'S INAUGURATION—PAGES 130–31

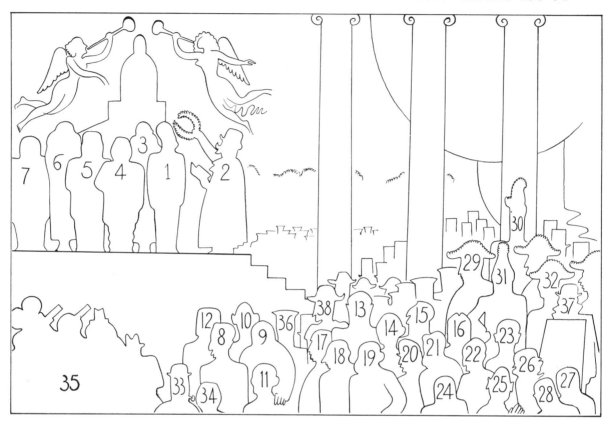

1	President F. D. Roosevelt	20	Senator Thomas Walsh
2	Chief Justice Hughes	21	John W. Davis
3	Mrs. Franklin D. Roosevelt	22	Senator Carter Glass
4	Vice-President Garner	23	Norman Davis
5	Ex-President Hoover	24	Newton D. Baker
6	Mrs. Herbert Hoover	25	Henry L. Stimson
7	Ex–Vice-President Curtis	26	Andrew Mellon
8	Alfred Emanuel Smith	27	Ogden L. Mills
9	James Farley	28	J. P. Morgan
10	Professor Raymond Moley	29	Ambassador Paul Claudel
11	Louis Howe	30	Sir Ronald Lindsay
12	Senator Joe Robinson	31	Oriental Ambassadors
13	Bernard Mannes Baruch	32	Oriental Ambassadors
14	Owen D. Young	33	Mark Sullivan
15	Senator William Gibbs McAdoo	34	Walter Lippmann
16	Governor Albert Cabell Ritchle	35	Gentlemen of the Press
17	Senator Claude Swansen	36	General John Pershing
18	Senator Pat Harrison	37	The Forgotten Man
19	Governor Herbert Lehman	38	The U.S. Navy